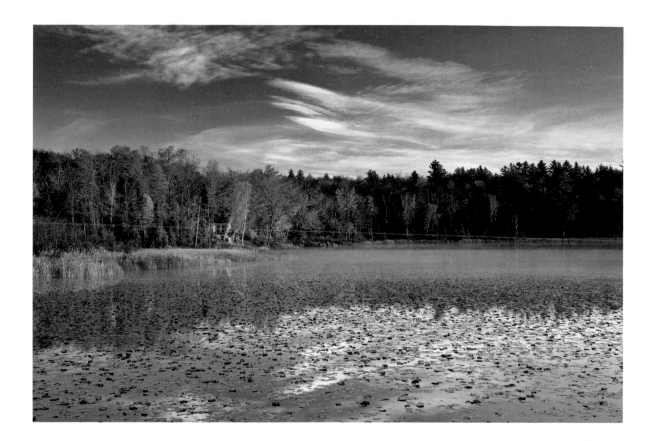

FINDING THE PICTURE
A location photography masterclass

Phil Malpas | Clive Minnitt

ARGENTUM

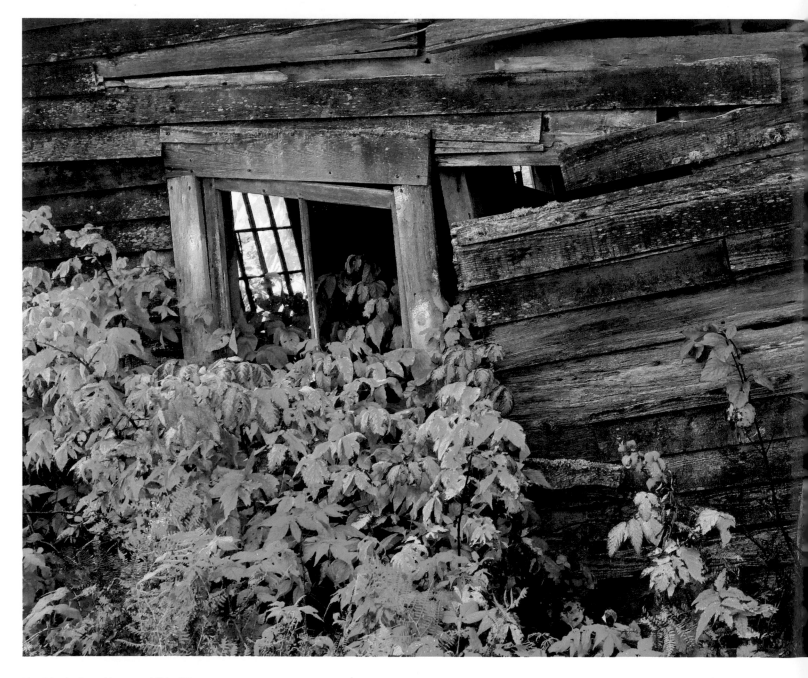

The Wonky Barn, Vermont, USA. **CM**

CONTENTS

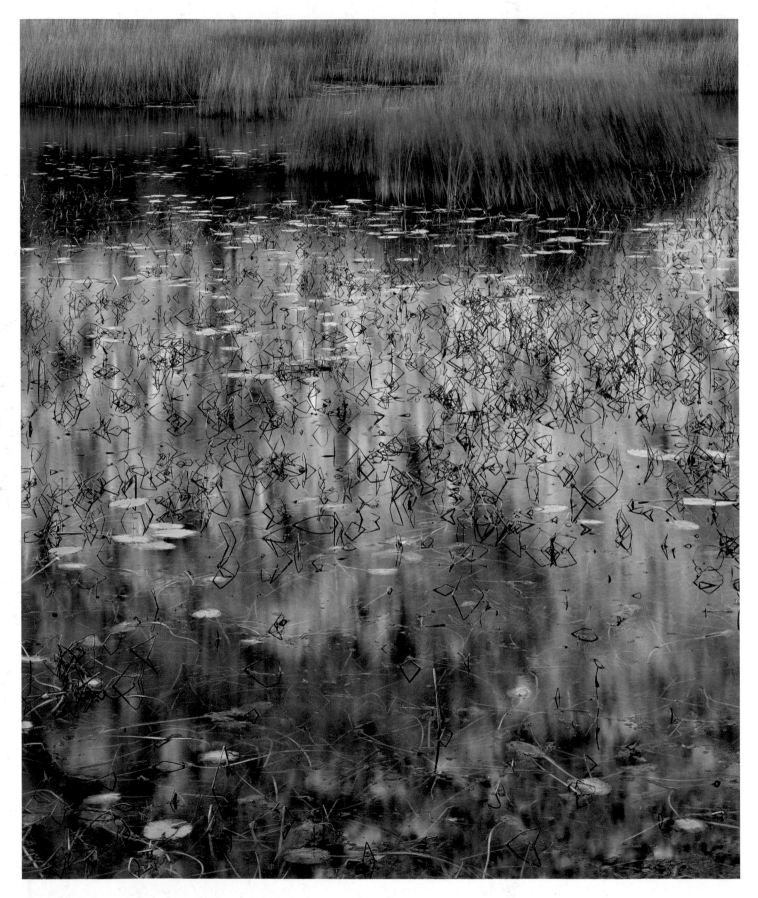

Foreword by Charlie Waite

All photographers, regardless of their experience and knowledge, can become temporarily 'blind'. They suffer a type of seizure in which their highly tuned seeing mechanisms go into spasm, and a catastrophic failure of their ability to recognise the potential merit of an image takes place.

As two highly experienced photographers and teachers, Clive Minnitt and Phil Malpas readily identify with this condition. Not only have they witnessed its distressing effects on many of the photographers who attend their Light & Land tours and workshops, but, as they would freely admit, they have occasionally suffered it themselves.

Thankfully, they have a whole range of remedies in their photographic medicine chest, remedies which they now share with us in this book. *Finding the Picture* will help anyone to quickly recover from this temporary blindness and start seeing fantastic images wherever they look for them. Using their wealth of experience and a selection of superb pictures they have found themselves, Clive and Phil show how to free up our imagination, find inspiration and make informed decisions about such crucial issues as colour, balance, light and timing.

Photography is an expression of our response to the world in a particular place, at a particular moment. In order to do full justice to this response, it is essential to 'define our objective' and then ensure that the execution results in an image that complies as much as possible with our artistic intention. This insightful and stimulating book offers assistance at every stage of this process. Continuing in the tradition of its predecessors, *Working the Light* and *Developing Vision and Style*, it explores and discusses both the photographic subjects themselves and the images to be made from them.

With their inspirational images and gentle, encouraging guidance, Clive and Phil steer us expertly through the often bewildering choices that photography presents to us, helping us to unlock our creative vision and 'find the picture'.

Facing page: Bear Brook Pond, Acadia National Park, Maine, USA. **PM**

Introduction

Working from experience | Inspiring others | Our approach to finding the picture

Developing your photographic skills from being able to make a simple visual record of a subject to a level where you can express yourself artistically through your images is very rewarding.

However, your development as a photographer will not always be a smooth and seamless process. In the same way that an author may suffer writer's block, every photographer, no matter how experienced or technically savvy, will suffer from being 'photographed-out' from time to time. Willpower and determination count for nothing when creativity dries up. And just as there will be moments when you lack the inspiration for a photographic subject, there will be other occasions when you have identified a suitable subject but are struggling to see how to tackle it.

As leaders of photographic workshops and tours, we are continually being asked for help in 'finding the picture'. Some people are born with a great ability to produce admirable results with little or no practice but most of us need inspiring, assisting or a little cajoling as to what, where, when and how to photograph. In *Finding the Picture* we aim to pass on what we have learned about identifying and making better images to anyone who wishes to learn. Think of it as a workshop in book form! **CM**

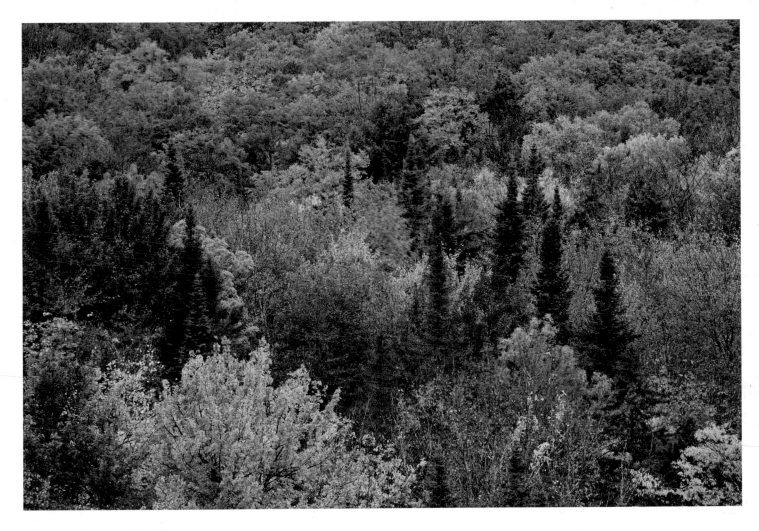

Fall colours, Vermont, USA. **CM**

Working from experience

Sharing ideas, pictures and photographic experiences can be a great help to the decision-making process we have to go through when seeking subjects. Put a group of enthusiasts together for a few days and there will be a never-ending flow of enjoyable photography banter.

Throughout the year, we take groups of photographers to a wide variety of locations in the UK and abroad. Beginners, amateurs and professionals join us to learn more about the subject that unites them all.

Lively discussions are promoted with, and amongst, our clients. We teach and learn and everyone has a valuable contribution to make. Critique sessions, in which participants are invited to show samples of their work, generate new ideas for the photographer and the viewers. Some of the most original and inspiring images we've seen have been made by clients who would have done anything not to show their work publicly. Their confidence and self-esteem has visibly grown as the workshop has progressed.

The principal role of the workshop leader is to take clients to locations that are considered to be photogenic spots at the most appropriate time of day and year, and with the most suitable lighting conditions. No matter how much planning has been done there is no guarantee of success. Changeable weather or unforeseen circumstances can scupper the visit at a moment's notice. As leaders, we aim to have a plan B close to hand if possible.

Our designated locations are carefully chosen, usually following a scouting trip, in order to provide the group with as many options as possible for good photography. However, the phrase 'you can lead a horse to water but you can't make it drink' is one of which we are fully aware. One of our most enjoyable and rewarding tasks is encouraging others to look for alternative subjects to photograph – particularly when they are adamant that all else has failed.

The idea for this book originated in a photography workshop. Long before we started to lead them ourselves, both Phil and I attended Light & Land workshops as clients. At one of the earliest sessions a fellow attendee asked Charlie Waite, our leader, 'So where's the picture?' Since then we have devoted much of our time at workshops – as either clients or teachers – to answering this question. This book is an opportunity to put our ideas, tips and suggestions down on paper. **CM**

Facing page: Val D'Orcia, Tuscany, Italy. **PM**

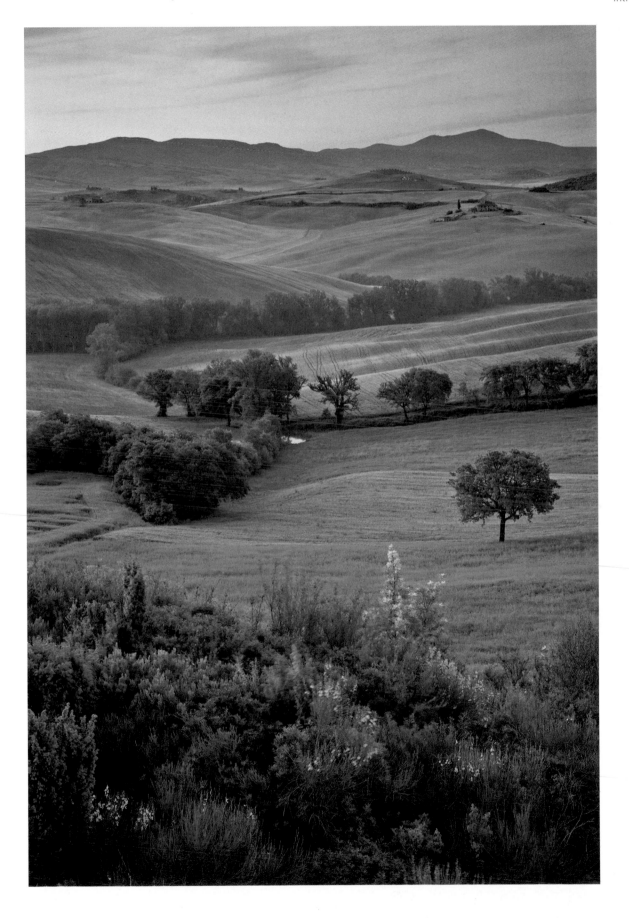

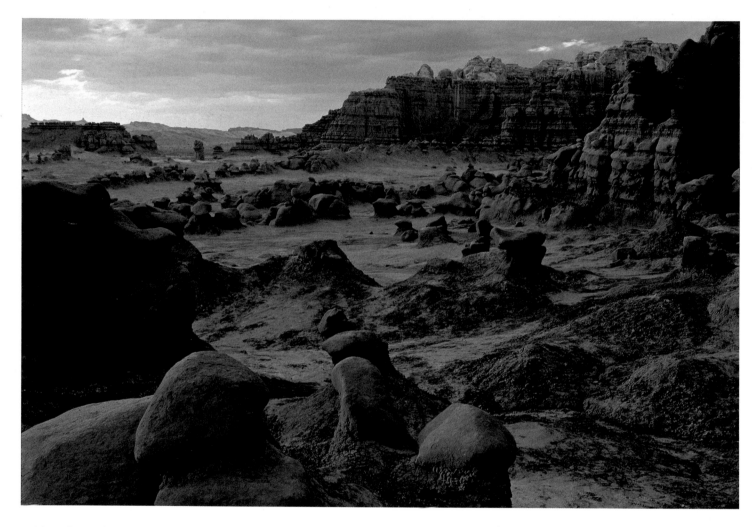

Goblin Valley, Utah, USA. **CM**

Inspiring others

Our daily lives are inundated with imagery, be it stills or moving pictures, in books, newspapers and magazines; on websites; and in adverts, films and tv programmes. We are bombarded with pictures whose origins were either speculative or the result of a commission. These pictures are used to tell stories either in their own right or subliminally; to illustrate a point; to record a moment, or to sell a product. For an image to be successful it has to generate a response from the viewer.

One of the aims of this book is to generate a response from you, the reader. It is unlikely that every image will appeal to you, but, as with its predecessors, *Working the Light* and *Developing Vision and Style*, the book is intended to provoke you into thinking laterally and inspire you to generate more of your own pictorial ideas.

Improving the standard of your own photography will, in turn, inspire others. It is incredibly rewarding if your work can lift the mood of those you show it to, make them see the world in a different light or give them the impetus to pick up a camera and make their own pictures. Inspiring others is not something we set out to do; usually it's a by-product of doing something well. Evoking such a response will give you a profound sense of satisfaction and increase your self-esteem.

Ever since we became interested in the medium, Phil and I have been inspired by other photographers. Charlie Waite, Joe Cornish, David Ward, Michael Kenna and Jim Brandenburg are just a few of those who have shown that dedication to work and a willingness to learn can drive them to exceed their own expectations.

Whilst it would be stretching the point to suggest that there are good images to be found everywhere you look, we hope this book will whet your appetite, spark your imagination and inspire you to widen your picture-making horizons. **CM**

Our approach to finding the picture

'You must have a really expensive camera!' We've both been on the receiving end of these words on several occasions and graciously accepted the backhanded compliment – before pointing out that it would be poor etiquette to inform a concert pianist that their music is so admirable because they play a top-notch piano, or an artist that their paintings are outstanding because they use an expensive paintbrush!

Spending large amounts of money on the latest high-tech camera equipment will not improve the quality of the picture content. An experienced photographer should be able to produce excellent images using almost any camera. Careful use of light and compositional excellence are equally valid when using a mobile phone camera or a 10 x 8 inch large-format view camera.

Purchasing expensive and sophisticated camera equipment may even have a detrimental effect – when the results do not match those anticipated. Disappointment does nothing for confidence and may put off the user from progressing further.

More important than investing heavily in the latest hardware and software products is being able to understand what makes a good picture and having a grounding in good photographic techniques. It's better to pass your driving test before buying a Mercedes!

The digital age has sparked off many a discussion over the use of technology in photography. Our philosophy has always been to strive for the best we can achieve before pressing the shutter – no amount of technological advances will help us to find the picture.

Where digital has brought benefits is in allowing the photographer to change the ISO setting for each frame; high-speed action shots can be immediately followed by low-light landscape photography with no requirement to change film. The provision of a histogram and instant replay of each image helps the photographer find burnt-out highlights and blocked-out shadows, allowing fine-tuning for improved results. Although this is really no different from the traditional method of using a hand-held spot meter and working out acceptable contrast levels.

To summarise, this book is not concerned with technological advances and our approach to finding the picture is the same whatever equipment is used – film or digital. **CM**

Facing page: Gondolas, Venice, Italy. **CM**

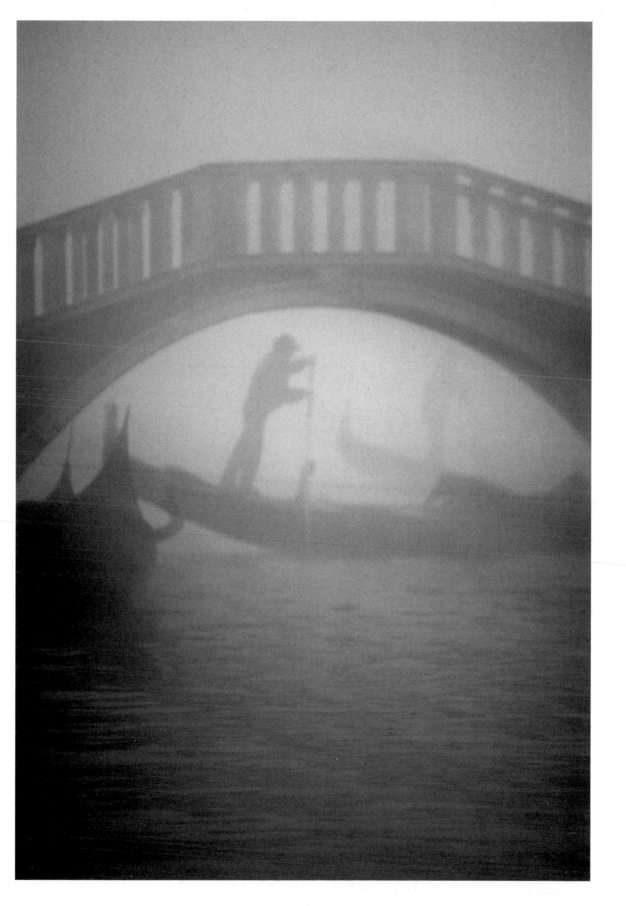

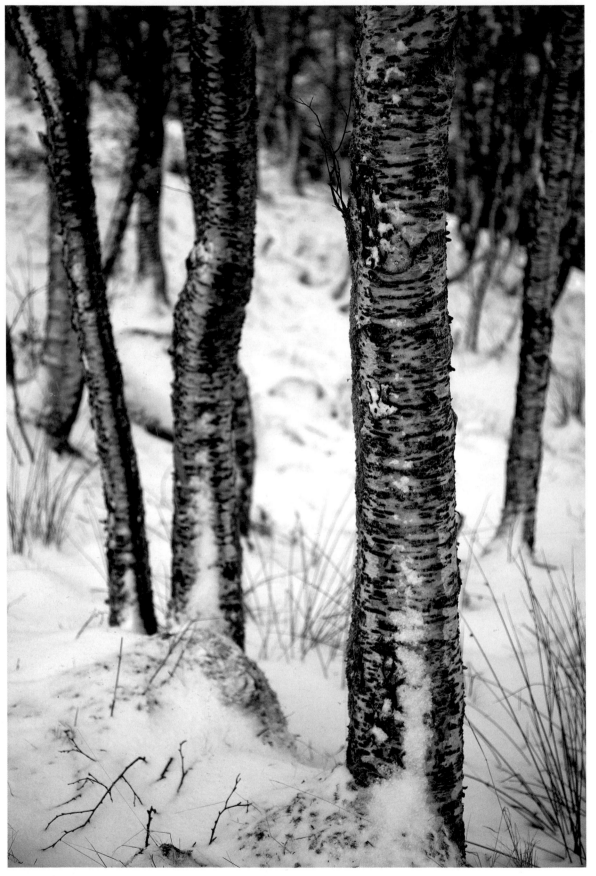

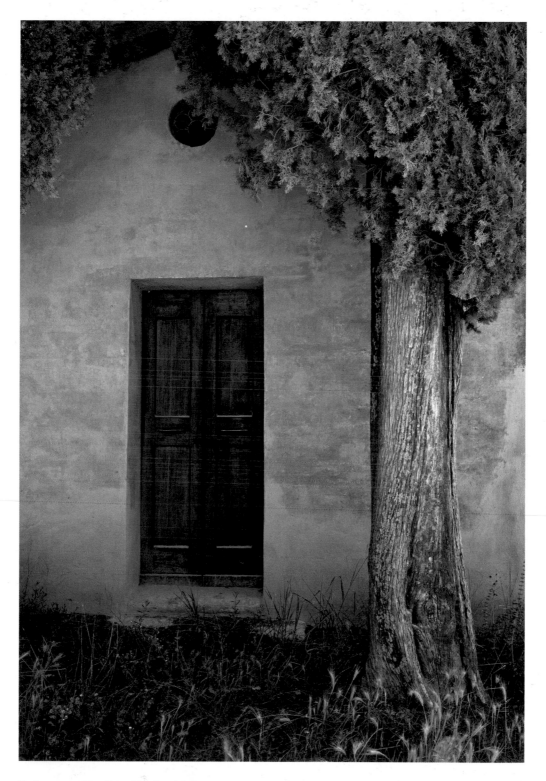

Facing page: Glen Etive, Scotland. **PM**
Above: Lucignano D'Asso, Tuscany, Italy. **PM**

Dial Beag, The Hebrides, Scotland. **PM**

Talk it through

If you have difficulty finding a picture, imagine there is someone with you to whom you are describing what you are seeing and how you aim to photograph it. If this doesn't help, tell your imaginary friend what you are stuck on and listen to your own reply. Then heed your own advice!

Where's the picture?

What kind of photographer are you? | On location: Derwentwater | Learning through experience | Seeing versus looking | On location: Bristol Airport

Being faced with a blank canvas is about as daunting as it gets for the photographer. When asked for the first time to make some 'artistic' photographs to frame and display on the wall, it can be almost as nerve-racking as making your first public speech! From some, the excuses will pour out: 'I've no idea what to photograph; I'm not inspired; there's nothing here for me; the weather's not right; the light is always better abroad.' Others will adopt the 'bull at a gate' approach and photograph anything and everything in their line of sight.

As with many things in life, a little preparation will save wasted time, effort and frustration. Photography is about being able to 'see' things rather than simply look at them. When we learn to observe what lies in front of our eyes in detail, we are able to slow down the photographic process and produce better results. Not only do we become more patient in our quest for excellence, but there is a marked change in the way we look at the world. **CM**

What kind of photographer are you?

Before your quest for a great picture begins, it is a good idea to identify the kind of photographer you are and the types of subjects you enjoy photographing. This will help you decide what sort of camera equipment, in particular which format, will best suit your approach. Many people mistakenly put the cart before the horse, purchasing a camera and lenses which are not suitable for the images they wish to make. There is little point buying an all-singing, all-dancing top-of-the-range SLR and an abundance of different focal length lenses if you need to be able to react quickly and easily to rapidly changing circumstances – in which case a good compact camera may suffice. Many professional photographers are adaptable in their approach and have a variety of camera formats from which they select the one most appropriate for their current project. If your only camera was a beautifully built 5 x 4 inch Ebony, you would be very unlikely to make a success of a social documentary project!

Ask yourself, what are my strengths, my interests and my passions? Think also about what you intend to do with the output from your endeavours – is it purely for home enjoyment or for commercial use, such as greetings cards, magazines, books, exhibitions, or billboard advertising? The larger your images are to be printed, the larger the film format or higher the specification of digital camera will be needed. Conversely, there is little point in purchasing expensive camera equipment which has far too high a specification for your intended use. It will be a waste of your resources.

Are you the hunter-gatherer type who sets off with camera in hand, hoping that something will catch your eye? Do you rigorously plan your ventures, with the sole intention of capturing a pre-visualised image? Or are you able to adapt and think laterally when things don't quite work out the way you had planned? Is your photographic style artistic or documentary – or a combination of both?

We both use a combination of approaches. Almost all our landscape, architectural and seasonal subject work is planned thoroughly. Adapting to whatever picture-making possibilities arise is also an important part of our approach. In all cases, being prepared usually guarantees success. **CM**

It takes effort
If everything was laid out for us on a plate with cast-iron guarantees that we will produce award-winning pictures each time we venture out with our cameras, photography would cease to be fun! We all have to work hard in order to improve the quality of our photography – the more effort we put in, the more satisfying it is when we see progress. Persevere; don't give up!

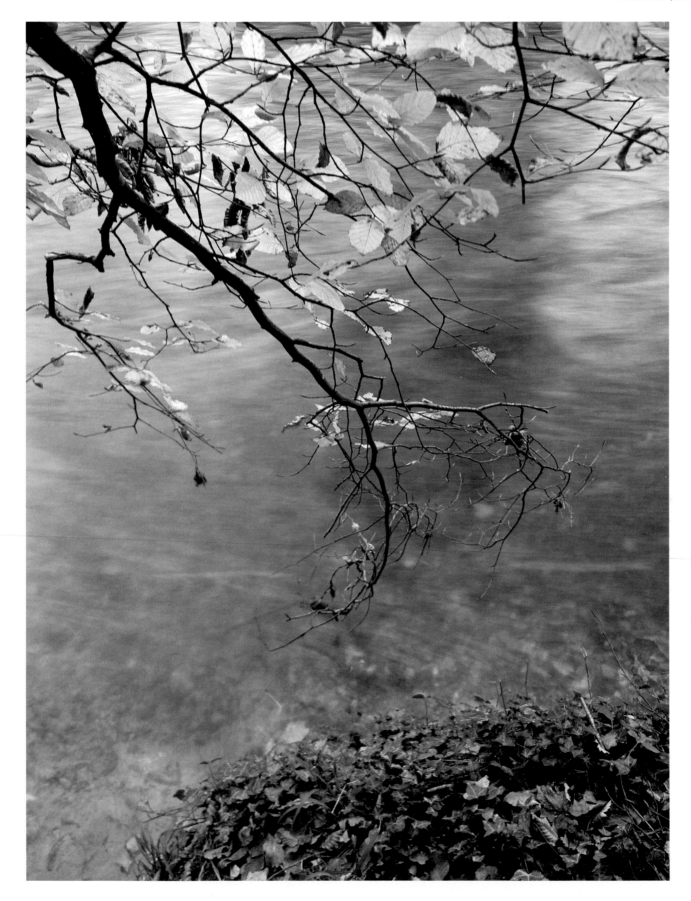

Be bold
Don't allow the fear of making mistakes to stifle your creativity.

p21 **River Plym**
Devon

Clive Minnitt

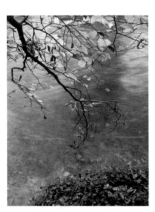

p21

p23

p23 **Lucignano D'Asso**
Tuscany, Italy

Phil Malpas

Inspiration: During a visit to Scotland with a group of photographers in Jan 2008, one of our party, Eddie Ephraums, wove his magic with a compact camera. He didn't have to venture far from the cottage to find pictures and his ability to see the 'simple' image, particularly in black and white, backed up my own theory that there are pictures everywhere. I decided to take a leaf out of his book and experiment with black and white.

The situation: Light levels were low. I wanted a fast shutter speed to freeze the branches but a slow shutter speed to show the movement in the water. I compromised on a medium shutter speed. A gentle breeze played havoc with previous attempts to capture the image, and I invented a few new expletives before I had finished.

Camerawork: Camera: Panasonic Lumix DMC-LX3,
Lens: Leica DC Vario-Summicron, 4:3 format
Exposure: 0.6 second at f2.2
Filtration: None
Other: Plus 0.3 exposure compensation, ISO 80

I should have waded in and removed the stick-like object from the bed of the river. I could clone it out in Photoshop CS3 but I have deliberately left it in as an example of how a photograph can be spoilt by not giving enough attention to detail. **CM**

I think the idea of Clive 'wading in' to the river should be encouraged! I disagree in that I don't think the stick-like object spoils the image, particularly because of his decision to convert to monochrome. For me this is a well seen and unusual composition. I'm sure Eddie will be flattered to hear of his influence on it. **PM**

Inspiration: I was initially attracted by the way this weathered post was being overwhelmed by the spectacular early summer vegetation. It was only on my return home that I realised that the 7 main poppies in the image form the shape of the number 7.

The situation: I was fortunate that Clive was driving at the time as if I had been behind the wheel I would have missed this opportunity. The post and flowers were directly at the side of the road on the passenger side of the car. I only had a fleeting glimpse to react to as we drove past.

Camerawork: Camera: Canon EOS 1DS MkIII
Lens: Canon EF 24-105mm f/4L IS USM at 67mm
Exposure: 1/60 second at f11
Filtration: None
Other: ISO 160

Red is an extremely powerful colour in any composition, especially when it forms only a small part of the total area. Once you have seen the number 7 in this image, it is difficult to put it from your mind. **PM**

A great example of an image that was achieved without any planning. We were scouting the area when Phil shouted 'Stop!' rather loudly as we passed this post. Now I'm also unable to look at the image without seeing the number 7. Perhaps it would make an excellent advertising image? **CM**

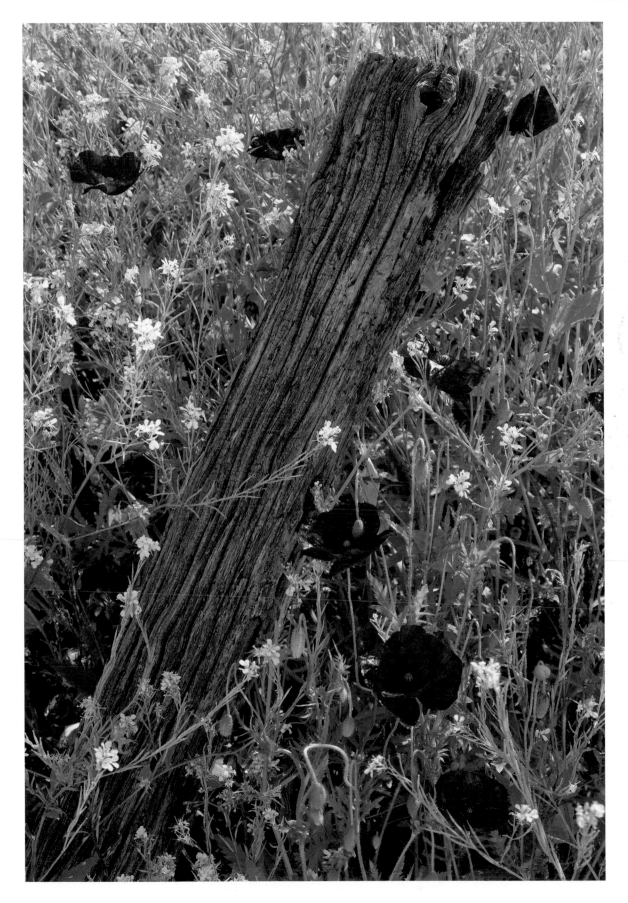

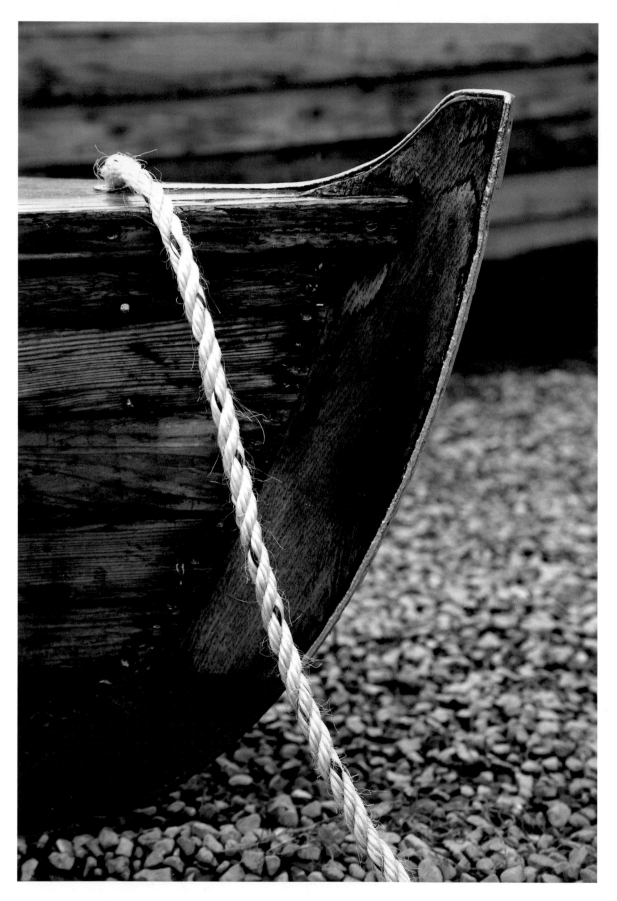

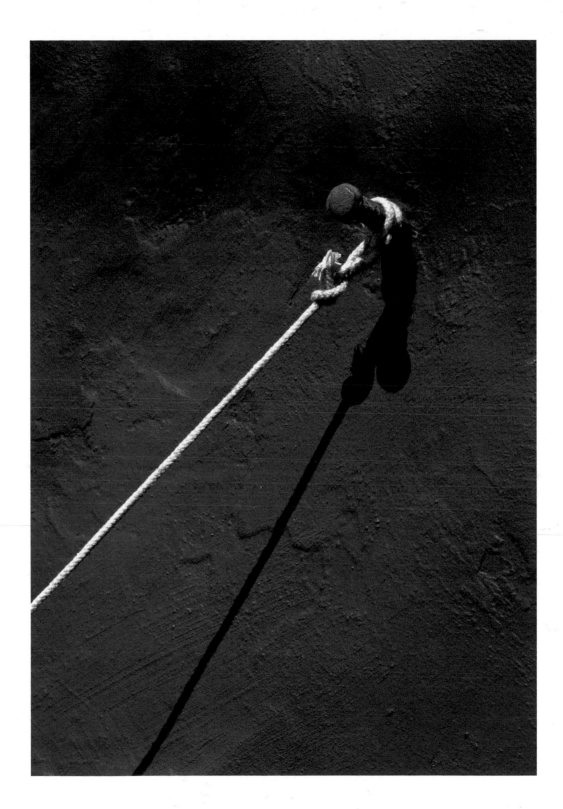

Attention to detail

Which details should you have included and which should you have left out? View images in Photoshop, rotate them 180 degrees and see what catches your eye.

Photographer's block
Everyone will have photographer's block from time to time – it's natural and is a healthy sign that we want to break out from our current way of seeing.

p24 **Shores of Derwentwater**
Cumbria, England
Clive Minnitt

p25 **Burano**
Venice, Italy
Clive Minnitt

p24

p25

Inspiration: The delightful Victorian rowing boats that line the shore of Derwentwater, near Keswick, provide wonderful alternative subjects to the more iconic views of the lake. Working with shapes, angles, ropes, oars and rowlocks held my attention for hours. Dull conditions helped to emphasise the exquisite colours and textures of the wood.

The situation: It was a still day with overcast conditions. An uninteresting grey sky put paid to any wider views of the lake.

Camerawork: Camera: Canon EOS 5D
Lens: Canon 24-105mm f/4L IS USM at 105mm
Exposure: 1/60 second at f6.3
Filtration: None
Other: Minus 2/3 exposure compensation, ISO 50

The position of the boat's bow against the rear boat is important, as is the focusing. The opposing curves give the image balance. **CM**

Clive and I regularly visit these rowing boats on our Light & Land Lake District tours. There are endless opportunities and in this image he has done a fantastic job of keeping it simple. This was clearly a case of what you leave out being more important that what you keep in. Compositions such as this require a surprising amount of care and attention and can take a long time to realise. **PM**

Inspiration: Trying to make a silk purse out of a sow's ear, photographically speaking, is often fun.

The situation: Burano was made for photography. Even the washing lines are worth a picture or two. It's perhaps as well there was something upon which to hang this line, otherwise I would have made a bolt for it!

Camerawork: Camera: Canon EOS 1
Lens: Canon 28-70mm L USM
Exposure: settings not recorded
Filtration: None
Other: Fuji Velvia transparency film, ISO 50

The light shadows falling on the top third help to tone down the brightness level. It's best not to look at this for too long or you will start to see extremely rude things appearing. **CM**

Prior to working on this book I don't believe I had seen this image and I absolutely love it! The richness of colour, its basic simplicity and the wonderful lighting all serve to deliver on all fronts. I do wish you hadn't mentioned the 'rude' things though Clive. **PM**

On location:
Derwentwater

Be prepared to experiment

What might experimentation look like? Camera magazines tend to suggest we try different techniques, but what about adopting different approaches to our photography? For example, look at the same scene and imagine photographing it as an artist, then as a documentary photographer. How does your interpretation of the subject differ?

'What have you brought us here for?' Even if the words weren't uttered, the expression said it all. The client was not having the best of days.

A tour to the Lake District, of the kind that Phil and I regularly lead, is one of our favourites and extremely varied in subject matter. The region is one of the most beautiful areas in England and one could imagine it was created with photographers in mind. The shores of Derwentwater, near Keswick, have many interesting features to photograph and a visit is always part of our itinerary. On one particular grey day we decided to stop and have our lunch near the lakeside, allowing for plenty of photography time before leaving for a location that was more suited to the poor weather, which looked set for the day.

There was an air of despondency about one or two of the group. It was understandable, as I suspect they had pre-visualised a panoramic vista shot in beautiful light. Unfortunately, their imaginations had all but dried up and needed re-igniting. We had to think laterally. The hoped-for images weren't going to materialise, so we had to change tack and become hunter-gatherers.

We sensed this early on and were able to offer suggestions for alternative ideas. Even on this dull day the light reflecting off the water was wonderful and the poles supporting the jetties stood proudly to attention, waiting to be captured in-camera. Black-and-white or sepia-toned images were a great possibility.

On the water's edge were about twenty or so Victorian rowing boats with oars and rowlocks intact. Many different shades of brown and tan stood out, as did the ropes which added an extra detail. Textures, shapes and patterns began to excite everyone, and imaginations – and cameras – sparked into life. On that occasion we were lucky; our most recent visit happened to be before Easter and the rowing boats had either sunk or were being kept under cover until the beginning of the tourist season. **CM**

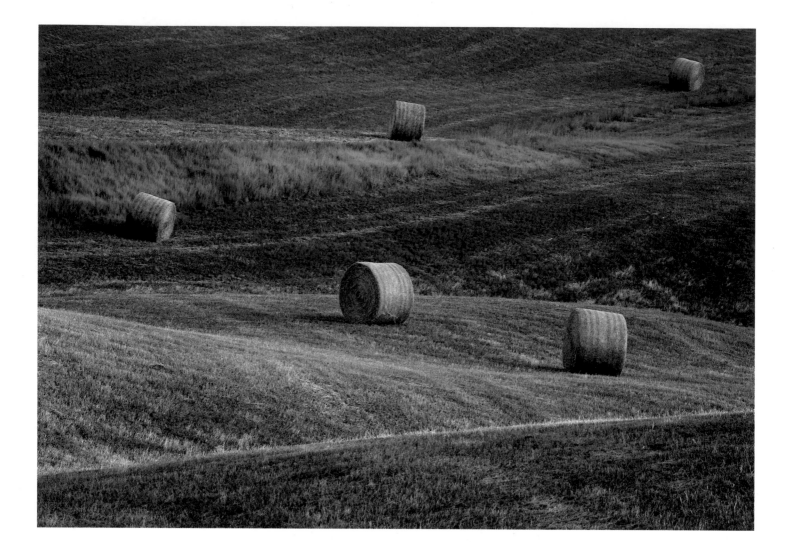

Seeing the light

The importance of light in photography cannot be overstated. Light is the vital ingredient which transforms a mediocre picture into one with mood and atmosphere. When you realise that it isn't so much the subject you are photographing but the light falling onto it or being reflected from it, photography becomes much easier to comprehend and good pictures are easier to find.

Learning through experience

Improving picture-finding skills is a gradual process. The formative years of most location photographers are likely to be spent wondering where and on what to train their cameras. They will have spent a great deal of time visiting different locations, either locally or further afield, and expanding their knowledge of the photographic possibilities. Areas that were once unfamiliar to them often become favourites.

Experience enables us to understand, to predict and to anticipate where pictures are to be found. It also makes us realise the importance of researching crucial information such as the best time to visit a location to capture the image we want. The Internet is an invaluable resource, from which you can extract weather forecasts, tide tables, times of sunrise and sunset, maps, satellite images and much more.

Setting yourself a specific photographic project is a good starting point for finding pictures, with a timescale that keeps you on your toes and retains your interest. Visit and re-visit subjects in a variety of weather and lighting conditions. Yes, it will mean photographing at unsociable times but the benefits will far outweigh the disadvantages, when you eventually experience conditions that most people only dream about.

If you start locally, you will benefit from being familiar with the area. Your house, garden, local parkland, leafy lanes and nearby woodland will be full of excellent possibilities. Your village or town will often have interesting architectural subjects to tackle.

Through experience you will learn that there is a right time and a wrong time to photograph a subject, in terms of light. Don't be afraid to make mistakes; it is part of the learning process and your experience will gather momentum as you progress from one project to another.

Talking to other photographers unearths masses of ideas. The camaraderie amongst fellow photographers is tremendous and very few keep their favourite locations to themselves, preferring to share what they know. Tapping into the experience of others is an important way of widening your knowledge and helps to clarify what it is you want to photograph.

When it comes to choosing a subject, there's no need to re-invent the wheel, as images of almost every subject and location under the sun have already been published. Study websites, books (e.g. travel and photography books), magazines, postcards, calendars and exhibitions – not to copy them but for ideas! **CM**

Develop your vision
Using a handheld viewer (an empty 35mm transparency mount or black card cut out to your camera format) is a great way of finding a picture before taking your camera out of the bag. There is a huge sense of freedom to working in this way. One becomes less focused on the end result and more open to possibilities.

How long does it take to find a picture?

Some highly respected photographers have returned to the same location over many years without managing to find the right picture.

p28 **South of Pienza**
Tuscany, Italy

Clive Minnitt

p31 **Pumpkins**
Near Waterbury, Vermont, USA

Clive Minnitt

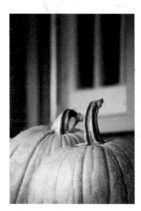

p28

p31

Inspiration: I was looking for relationships between different elements within the scene. Here, there were a few 'Z' shapes working together – as the sun went down over the yardarm.

The situation: During a photographic tour to Tuscany, the group was photographing from higher up the hill. I spotted what I thought might be a better viewpoint about a mile away and jogged down to have a look. The track ended up at a farmhouse and the owners kindly gave permission for the group to have access to their land. I called Phil on the walkie-talkies but alas, no response. Jogging back uphill felt more like ten miles.

Camerawork: Camera: Canon EOS 5D
Lens: Canon 100-400mm f/4.5-5.6L IS USM at 310mm
Exposure: 2 seconds at f22
Filtration: None
Other: ISO 50

The bales and the folds of the field have been used to lead the viewer's eye across the picture. The lighting helps to add atmosphere and a little drama. **CM**

Clive says that the lighting 'helps', but I think it is pivotal to the success of this lovely image which may have been a bit flat without it. When greeted with a subject like this there is only one solution to finding your viewpoint and that is a lot of walking around it. Congratulations are due to Clive for doing this, especially after all that running! **PM**

Inspiration: A challenge – how to incorporate the pumpkins and the brightly coloured background in a meaningful composition?

The situation: Bright colours seemed a good way of attracting customers to the pumpkin farm. It certainly attracted the attention of colour-seeking photographers. Thousands of pumpkins lay in rows on the ground as the build-up to the annual Halloween festivities began in earnest. The windows and frames were in a bit of a state so I decided to opt for a wide aperture and have them out of focus.

Camerawork: Camera: Canon EOS 5D
Lens: Canon 100-400mm f/4.5-5.6L IS USM at 400mm
Exposure: 1/125 second at f5.6
Filtration: Polariser
Other: ISO 200

The image was achieved in stages and took quite a while to complete. Composition, focusing, then a polariser to reduce the glare on the pumpkins but not so much that it took away all the reflected light from the windows. It makes me smile! **CM**

Clive has worked extremely hard to incorporate the pumpkins and the garishly painted window into a coherent composition. I know from experience how difficult this is at this location. I wonder if it might have been desirable (or even possible) to create a slight gap between the two pumpkin stalks? **PM**

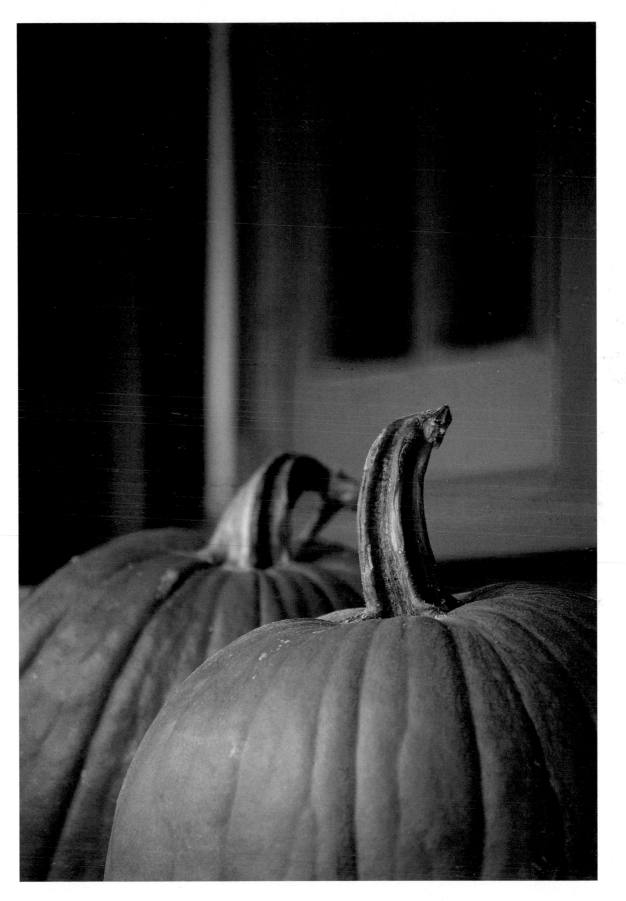

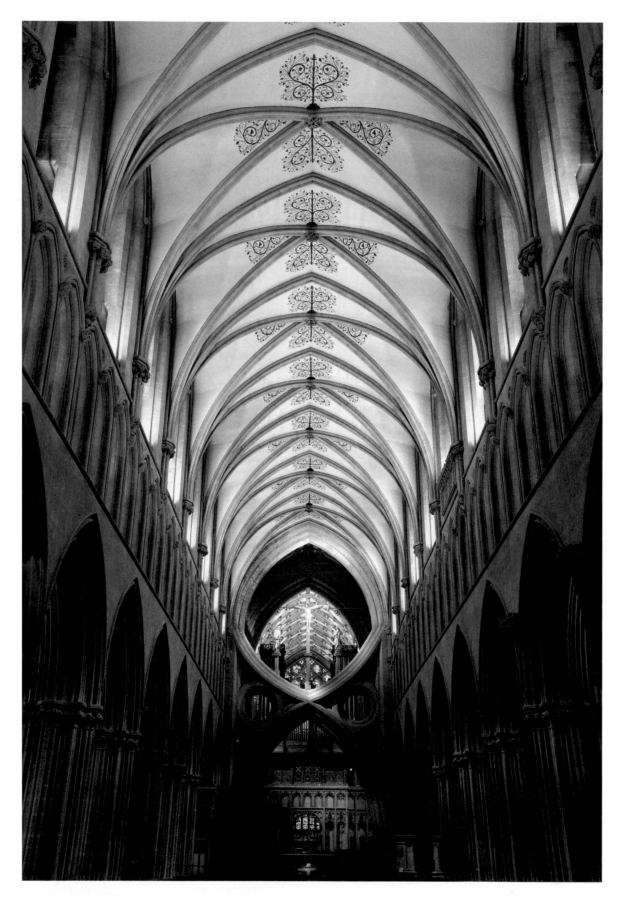

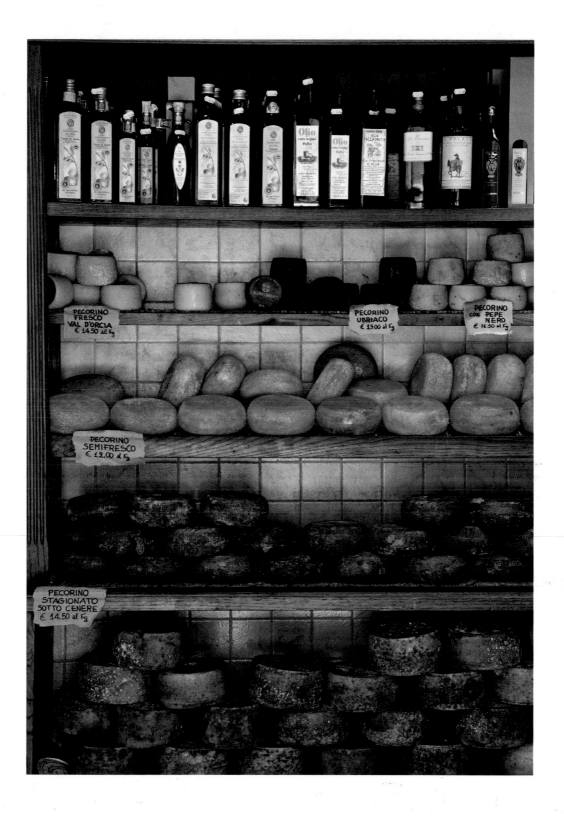

What comes first?
Do you always put technique first before considering how you feel about the subject?

The quest for a good picture
With location photography finding a picture is a quest and not an exact science.

p32 Wells Cathedral
Somerset, England
Phil Malpas

p33 Cheese and oil
Pienza, Tuscany, Italy
Phil Malpas

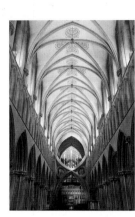

p32

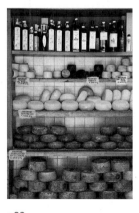

p33

Inspiration: I have been fortunate to photograph the interiors of a number of our great cathedrals and always find them inspirational. Of course, it was the architect's original intention to engender a sense of wonder and awe in the congregation. A reaction that is impossible to avoid, even today.
The situation: This image was taken at the end of the day during an 'On Location' shoot for *Outdoor Photography* magazine. Most of the tourists had left and the amazing acoustics allowed the practising choir to create a magical atmosphere.
Camerawork: Camera: Canon EOS 1DS MkIII
Lens: Canon EF 16-35mm f/2.8L II USM at 35mm
Exposure: 2.5 seconds at f14
Filtration: None
Other: ISO 200, highlight tone priority set.

I selected a wide-angle lens in order to capture the sense of space and airiness within the cathedral. Consequently a slight convergence of the verticals was inevitable as I pointed the camera upwards. I don't mind this, though, as I feel the image is all about the light and the vaulted ceiling leading to the famous 'scissor arches'. **PM**

Experience of the qualities of light played a big part in the making of this image. During the morning, photography was best kept outdoors in the brighter conditions. The cathedral interior was deliberately saved for the forecasted, cloudier afternoon when there would be less contrast. The wisdom of this is borne out by the resulting picture – there is detail in all the shadow and highlight areas. **CM**

Inspiration: These small Italian shops are incredibly photogenic, something that is missing from the huge supermarkets we are accustomed to in the UK.
The situation: In order to capture this image I had to stand in the doorway of this small shop. A lack of customers when I first arrived soon changed to a real rush and I lost count of the number of times I had to move my tripod out of the way to let customers in or out. I hope I didn't annoy the shopkeeper too much!
Camerawork: Camera: Canon EOS 5D
Lens: Canon EF 28-135mm f/3.5-5.6 IS USM at 95mm
Exposure: 1 second at f11
Filtration: None
Other: ISO 50

I would have been happier if the one cheese on its side with the red label facing us was slightly further to the left on the shelf. Of course my position in the doorway was already precarious and I couldn't risk the shopkeeper's wrath by attempting to move it. I also wonder if it might have been better to crop tighter and make this just an image of cheeses. **PM**

The danger is that you could fine tune this composition, take a bit off here and there, spend all day doing it and end up with nothing! I like it exactly as it is. The bottles of oil complement the cheeses and sit on the most suitable shelf from a compositional point of view. Most people would pass by this picture opportunity. Experience helps to identify what will work and what won't. **CM**

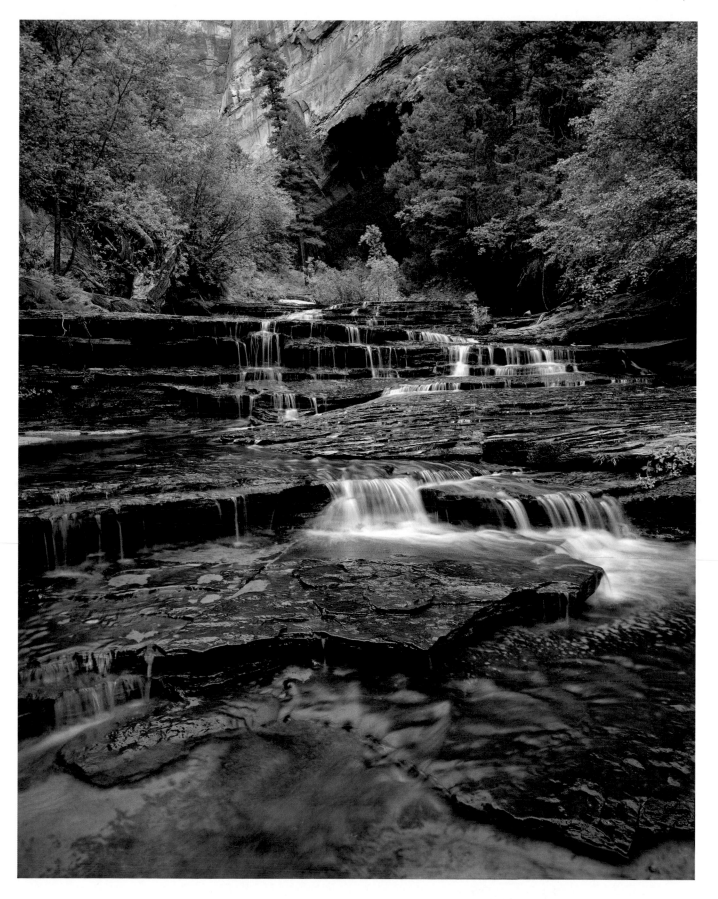

Slow steps

Our continual quest for the image will inevitably take us three steps forwards and two (or three) back.

p35 **Archangel Cascades**
Zion National Park, Utah, USA
Phil Malpas

p35

p37

Inspiration: These fantastic rocks in the Left Fork of North Creek in Zion National Park were the initial attraction for me in making this image. Slightly to the right of this position were some delicate, red flowers that I had hoped to include, but the overall balance of the composition meant that in the end I selected this viewpoint.

The situation: This image was made at the end of a long hard day and we were faced with a good few hours walk to the car in the gathering gloom. Consequently I was working quickly and although I noted a small dry patch of rock in the foreground that needed wetting, it was only on my final exposure that I remembered it. Fortunately this final exposure was correct, but this means I only have one useable sheet of film of this composition.

Camerawork: Camera: Ebony SV45TE
Lens: Schneider Super-Angulon 90mm f/8
Exposure: 1 second at f22
Filtration: None
Other: Fujichrome Velvia Quickload, ISO 50

By using rear tilt on my view camera I was able to emphasise the wonderful plates of red rock and make them loom in the foreground. I worked hard in choosing my viewpoint to ensure that the foreground rocks were balanced within the frame and also to let the running water lead the viewer's eye from foreground to background. **PM**

The curved foreground plate softens what is essentially a hard and rugged environment. Although Phil was unfamiliar with this area, his experience played a big part in knowing what to include and, equally important, what to leave out. **CM**

p37 **North Creek**
Zion National Park, Utah, USA
Phil Malpas

Inspiration: The red rocks in the Left Fork of North Creek in Zion National Park are spectacular. I wanted to bring out this rich colour so I moved in close and filled the frame, trusting Velvia to work its magic.

The situation: This small channel has been cut through the rock over many years. The section I chose to isolate is about six feet from top to bottom. The area is difficult to get to, being three or four miles from the car with no recognisable pathways. One particular section requires the use of a rope both to climb up on the way and to abseil down on the return.

Camerawork: Camera: Ebony SV45TE
Lens: Nikon Nikkor M 300mm f/9
Exposure: 4 seconds at f22
Filtration: None
Other: Fujichrome Velvia Quickload, ISO 50

This image is all about texture and colour. There is nothing to give a sense of scale, which challenges the viewer and adds a sense of mystery. I particularly like the reflected light on the inside of the channel, which is picking up a hint of the blue in the sky overhead. **PM**

The diagonal line makes for a much stronger composition than a vertical or horizontal one would have given. Phil has also made a conscious decision not to use a polarising filter, which would have drastically reduced the highlights on the rock. Retaining them confirms that the rock actually has water running over it. **CM**

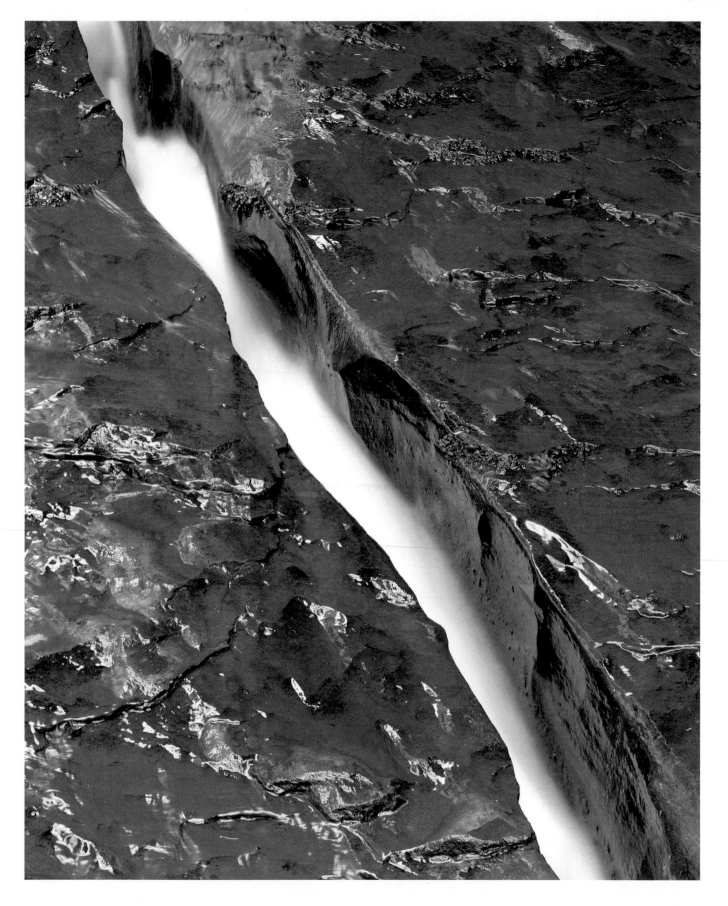

Seeing versus looking

Photographers are not the easiest people with whom to go for a social walk, whether in a rural or an urban setting. They can drive non-photographers to distraction, constantly pausing to take in the surroundings and make mental images as they go. This is all part of the seeing process, which has become a part of their daily lives.

Most people look but don't see! Perhaps this is overstating the case but experience tells us that many are inclined to look at a scene and remember it in its entirety but miss seeing the detail.

Try this exercise – step outside and carefully study the scene in front of you for a few moments. Then look away. What do you remember seeing?

This is not meant to be a memory test but a way of helping you to understand what it is you observe. It would be surprising if you recalled anything connected with the weather or what the light was doing. Was it windy, calm, frosty, misty, sunny or cloudy? Was the lighting flat or full of shadows and highlights? Was the sun low or high and what was its angle in relation to you? Was light being reflected off some elements onto others? In what ways did the conditions affect the subject?

It's also unlikely that you will have noticed any relationships occurring between objects in the foreground and background; between land and sky or moving and static objects. Were there patterns, lines, interesting shapes, gaps, angles, reflections; complementary colours or colour clashes? Did you see different types of vegetation or seasonal nuances such as trees which have shed their leaves? Did you see any pylons, telegraph poles, airplane trails or anything else that might impinge on your creative vision?

And how did you actually survey the scene in front of you? Did you only look straight ahead or up, down and sideways? Did you see with a 'wide angle' view or a selective, 'telephoto' one? Seeing and observing is fundamental to good photography and it is a skill that can be learned through practice. Try to get into the habit of carefully analysing the scenes you encounter whether or not you plan to photograph them. It is also good practice to study light and how it affects subjects, not just when it is dramatic but whatever its quality and characteristics. **CM**

Pre-visualise the picture

What is the quality of light you are seeking? Imagine the end result then ask yourself when you should arrive at your location so that you have every chance of witnessing your pre-visualised light. Although we are at the mercy of the weather it is possible to time your visits in order to give you the best chance of success.

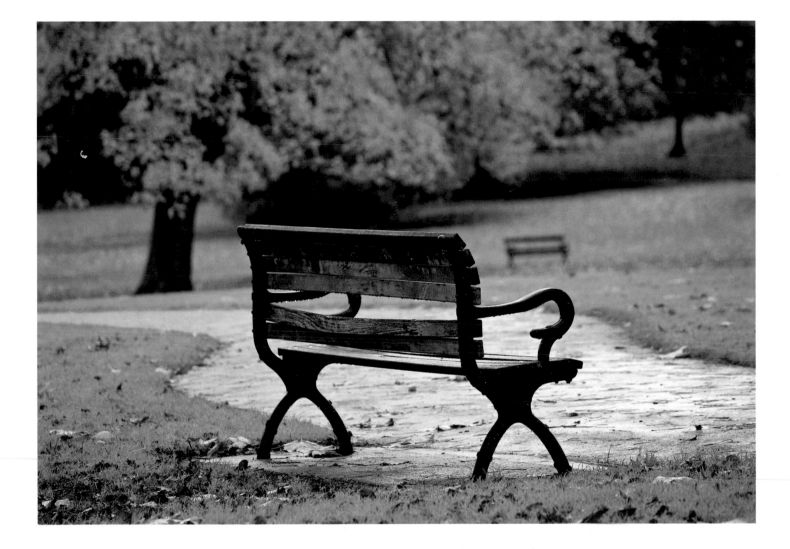

Narrowing the choices
Choice can stifle creativity. Often it is easier to work at a location where there is only one subject to photograph and be forced to work with it, rather than spending time weighing up different options and settling on none.

An invaluable resource
The Internet is not only useful for researching specific views of a location; it's also invaluable for finding out about the geology, flora and fauna of an area.

p39 St. Andrew's Park
Bristol, England

Clive Minnitt

p41 The Park Hotel
Barcelona, Spain

Phil Malpas

p39

p39

Inspiration: The park has a number of strategically placed benches and it's no secret that I have a penchant for a good bench. It stems from a project I did a few years ago, when I was invited by an American photojournalist to work with her, photographing benches in many regions of Switzerland. The Swiss really do know how to position a bench.
The situation: Late afternoon on a cold, dull, damp November day – perfect for saturated colours on the trees. A polariser helped reduce the glare from the leaves and path.
Camerawork: Camera: Canon EOS 5D
Lens: Canon 100-400mm f/4.5-5.6L IS USM at 180mm
Exposure: 0.5 seconds at f5.6
Filtration: Polariser
Other: Minus 1/3 exposure compensation, ISO 50

Fine-tuning my composition here was important. The positioning of the two benches had to be precise. The colours on the back of the nearest bench formed a good relationship with the trees. I decided to have the trees out of focus to give more emphasis to the bench and am pleased with the result. **CM**

Some would say that Clive has an unhealthy obsession with benches! Being an expert on the subject has allowed him to imagine a great result. Note the importance of the gap in the back of the near bench. If it wasn't there the foreground bench might create too much of a barrier at the front of the composition. **PM**

Inspiration: After ascending this fabulous staircase to our rooms during a photographic tour to Barcelona and the Pyrenees, we all knew that we had to photograph it.
The situation: The composition was made looking down from the top floor of the hotel, which was slightly nerve-racking. The ND grad was used to hold back the window light on the floor below me. A number of people climbed the stairs during the exposure, but fortunately they moved fast enough not to register on the film.
Camerawork: Camera: Ebony SV45TE
Lens: Schneider APO Symmar 150mm f/5.6
Exposure: 60 seconds at f22.5
Filtration: 0.45 ND hard graduated
Other: Fujichrome Velvia Quickload, ISO 50

Compositionally this is a fairly straightforward approach. One interesting factor for me is that different people seem to prefer viewing the print different ways and will often rotate it to discover their preference. For me, it was always meant to be a portrait, as shown here, which interestingly isn't the way the camera was oriented at the time I pressed the shutter. **PM**

The hotel was busy with guests scuttling here and there. Only our group appeared to show any interest in this spiral staircase. 'Seeing' involves so much more than simply looking. It comes with practice, and this is a carefully composed image which has a wonderful sense of ambiguity – are we looking up or down? Thank goodness Phil's tripod is sturdy! **CM**

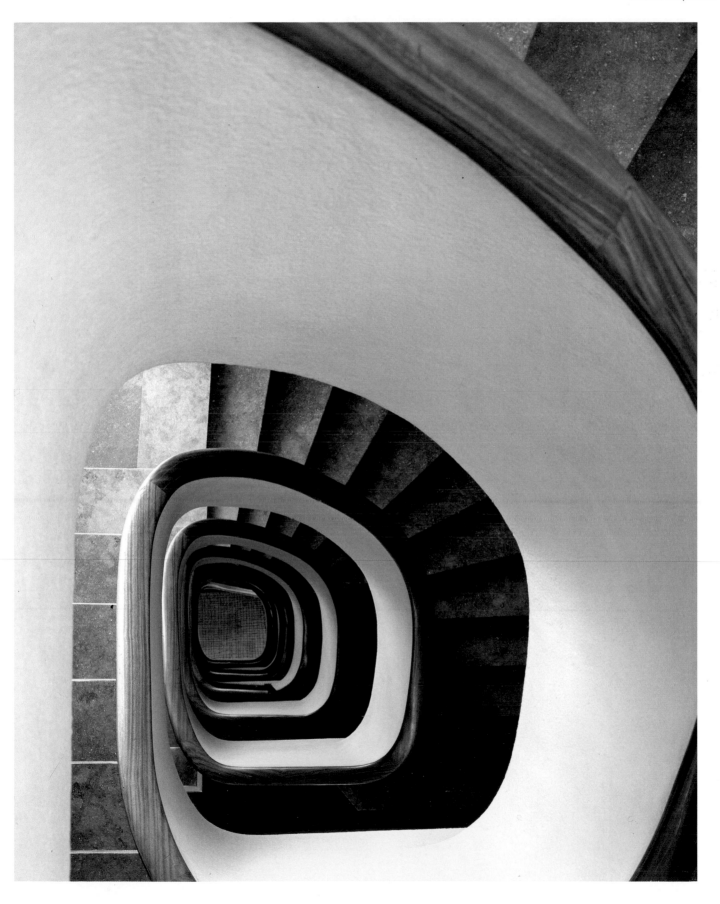

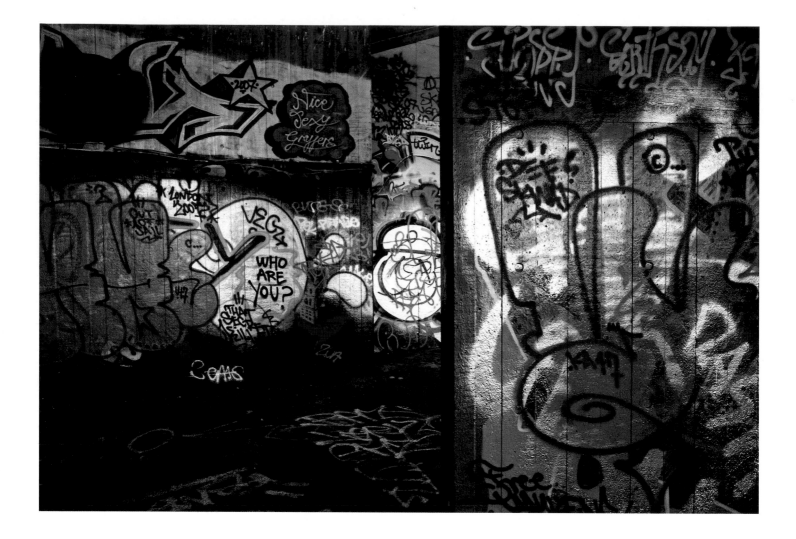

Observation

As photographers, we're sometimes accused of seeing the world only through a viewfinder. The picture-finding process is a continual one, which can border on an enjoyable obsession, but it will improve your powers of observation immeasurably.

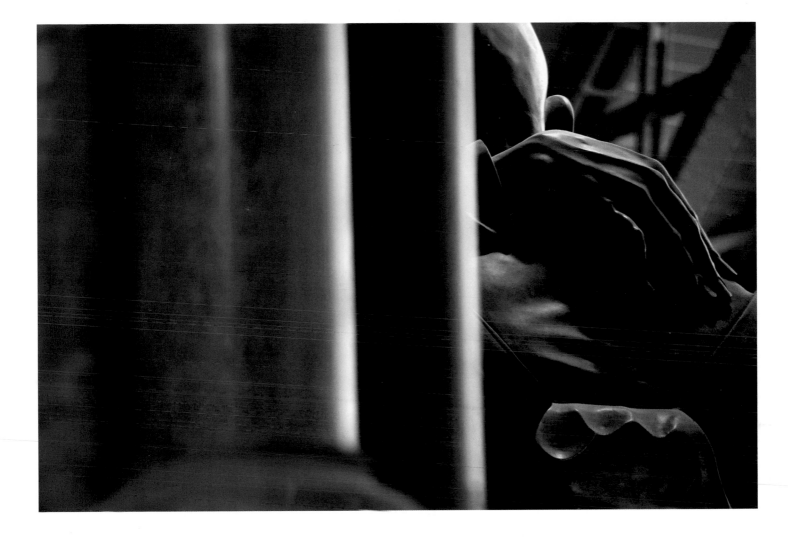

Slow down

Unless you have only a few moments in which to capture your picture, try to slow down the whole procedure. A rushed image is unlikely to be your best. Using a tripod will allow you to step back from the camera for a moment, whilst keeping it in situ. You will then be able to see if you have selected the best option, and will have more time to fine-tune your composition.

Personal satisfaction

Create your pictures primarily for yourself – it's important to enjoy your own artistic endeavours.

p42 **South Bank**
London, England

Phil Malpas

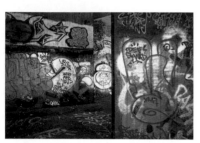

p42

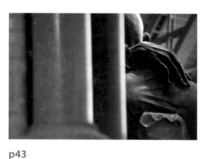

p43

Inspiration: The initial attraction for me was the spectacular colour of the graffiti. After a while my fascination switched to the artists themselves and watching them create their masterpieces became highly absorbing.

The situation: This is the Skate Park beneath the Queen Elizabeth Hall. It is an ever-changing scene as new artists block out the limited wall space and paint over the designs that were there previously.

Camerawork: Camera: Canon EOS 5D
Lens: Canon EF 17-40mm f/4L USM at 26mm
Exposure: 1/8 second at f16
Filtration: None
Other: ISO 400

It was quite dark in this subterranean world and I was really pleased with the way the silver paint seems to glow. I decided to select a composition that had elements close to the camera on the right whilst showing the larger area to the left. As this was for a magazine article, care was needed to ensure that nothing that could be considered offensive crept into the frame. **PM**

I could look at this picture for hours, there is so much of interest. It is said that patience is a virtue – Phil had to bide his time waiting for his moment. This worked in his favour, especially as the image wasn't dependent upon a single instance of light. It slowed down the picture-making process, giving him time to consider all aspects carefully. **CM**

p43 **The Meeting Place**
London, England

Clive Minnitt

Inspiration: The sculpture is much photographed by those who pass through the station. I set myself a challenge of producing an image that suggested the location without being obvious.

The situation: A busy concourse made working close to the sculpture difficult. Using a longer lens enabled me to photograph it from a quiet spot further away. Special permission had to be obtained from the station management when photographing using a tripod. The resulting image was needed for a magazine article, and we had only a few hours in which to capture an image that would appeal to, and hopefully inspire, the readers.

Camerawork: Camera: Canon EOS 5D
Lens: Canon 100-400mm f/4.5-5.6L IS USM at 400mm
Exposure: 0.6 second at f7.1
Filtration: 0.3 ND hard graduated
Other: Minus 1 exposure compensation, ISO 50

I was in danger of over-complicating the image so I selected a wide aperture in order to render the foreground and background out of focus. This made the sculpture stand out in the warm, late-afternoon, winter light. **CM**

Clive worked extremely hard to discover this viewpoint. The obvious composition is to photograph the statue as a silhouette against the station roof, but he has rejected this option and worked to find something of his own. The use of differential focus is spot on and I love the overall colour palette. **PM**

On location:
Bristol Airport

'We need an eye-catching front-cover image for our magazine – by Friday. Can you do it?' the client asked.

The assignment involved a visit to Bristol Airport, known at the time (the mid 1990s) as Bristol Lulsgate Airport. A total redevelopment was about to commence, which would upgrade the airport's status to 'International' and was the subject for the main feature in the first edition of the revamped magazine LINK – The Business Magazine for the West.

I received security clearance and was allowed to explore most areas on condition that I was accompanied by a member of security. Dull conditions during my 'recce' did little to inspire me and I had great difficulty imagining even a half-decent picture opportunity. Panic!!! Messing this up was not an option. I had to provide a stunning image! Not only that, the editor's brief demanded that the image lead from left to right and included space for a title, top right, and some information and a logo, bottom right.

I hoped to bag the picture in one visit as I didn't want to end up working under pressure at the last minute. The weather turned for the worse and my first two visits were non-events. Time was against me and with one day to go before the deadline I returned yet again, nervously to say the least, for one last attempt, severely testing the patience of the security officer.

As I was about to leave the airport apron, having failed to find anything remotely suitable, I turned to look at the three parked aircraft for a final time. At that precise moment, a single ray of light pierced the dense black cloud and caught the rear fuselage and tail of one of the planes, giving it the wow! factor.

The security officer recoiled in amazement as I screamed 'Yes!' Thankfully he allowed me to climb the steps that led up to the front door of the aircraft, so that I could get a close-up view of the fuselage and tail. What I didn't need at that stage, as I worked frantically to record the scene as artistically as I could, was to have several female cabin crew try to impress upon me that they were worthy of being photographed as they draped themselves over the handrail! Seconds later I was asked to leave as a stream of passengers crossed the tarmac to board the plane. **CM**

Be adaptable
Don't allow yourself to be blinkered. Concentrating solely on your favourite subject matter may cause you to become pigeon-holed, thus limiting your creative side. You may miss out on subjects you have never previously photographed or even thought about. Treat yourself to a change – as they say, it's as good as a rest!

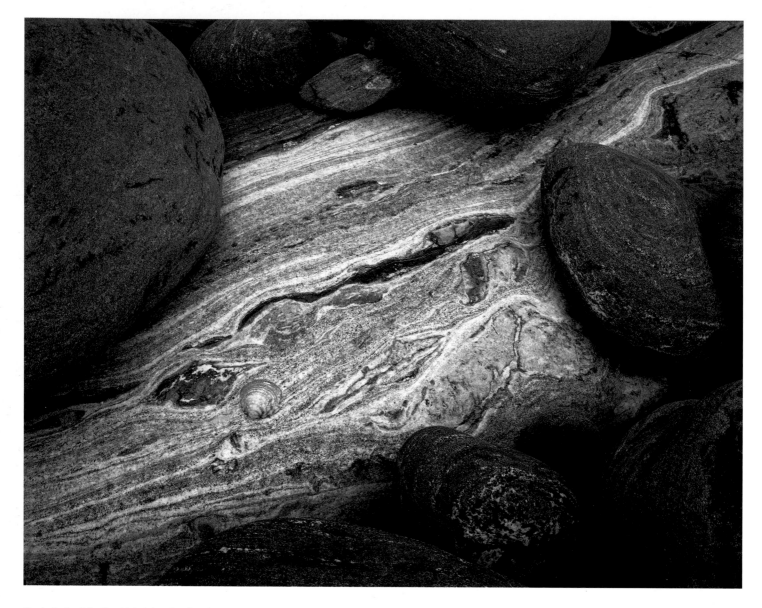

Bagh Steingidh, The Hebrides, Scotland. **PM**

Don't allow technology to rule
Try taking some pictures with the aim of doing no post-capture computer work, trusting solely in your camera skills and vision. Go one step further and photograph without referring to the LCD screen. How much are you relying on your editing skills rather than visualising the picture?

Why we take photographs

A connection with the subject | On location: The Outback | Capturing the moment | Expressing ourselves | On location: Santorini

There is no simple answer to the question 'Why do we take photographs?' It is likely to be different for each of us and will also vary according to the circumstances. Image making is often a passion and for some the desire to capture ever more satisfying pictures can border on obsession.

For many of us, the simple fact that we bought or were given a camera with which to take photographs was enough to spark our earliest interest. Initially there was always that nervous anticipation to see if the photographs 'came out', and we would be satisfied with any image, regardless of the faults we could see in it. Even in the digital age this can still be the case. It is just that in the modern high-speed world we get that feedback a few seconds after pressing the shutter rather than having to wait a week or more for the prints to arrive in the post.

The key point is that as beginners we are often satisfied merely to record the world around us and rarely feel the urge to take things further. As with any artistic endeavour, our journeys as photographers can take a lifetime to complete and our aspirations and aims change throughout. Questioning why we take photographs can help us to improve and gain even greater satisfaction from our image making. **PM**

A connection with the subject

A deep affinity with, and knowledge of, your subject will enable you to better interpret it in photographic terms. The ability to connect with a subject shouldn't be underestimated and in many ways you can benefit from concentrating on photographing things that interest you on some other level.

For many people this connection can be as simple as a love of the mountains or the coast and it is likely that you may have already invested a great deal of time in locations that appeal to you. Make the most of this investment. You are far more likely to make exciting images of subjects that engage you emotionally and this will, in turn, help you to connect with the viewer. A good understanding of all aspects of your subject will be clearly represented in the images you make.

When we see amazing wildlife photographs in books and magazines we tend to forget that in order to make these images, the photographer may have spent years studying the subject, its habits and likely behaviour. Similarly, many successful flower photographers have an intimate knowledge of the blooms they depict, which allows them to accurately represent their subject in print. Sports photographers need to anticipate where and when the decisive moment is likely to take place and use their knowledge of the sport in question to capture the best image.

Landscape photography usually goes hand in hand with a passion for the great outdoors. This in turn leads to an interest in the weather, and in maps, guide books and articles written about particular locations. All these are tools that can help you to improve your landscape photography, by helping you to predict when, where and in which conditions the very best images might be obtained.

If you come across a photograph that inspires you, stop and ask yourself how it was that the photographer managed to be there at that particular moment and to subsequently convey that moment to you. It is unlikely that this was achieved through pure chance. Inspirational photography usually comes from those who have been inspired by their subject, and have developed an intimate connection with it. **PM**

How to see with fresh eyes

Look at a potential subject and imagine it through the eyes of your favourite painter or photographer. Think how they would approach the subject and attempt to better what they have produced. It's easier said than done, perhaps, but practice will help you to develop your own approach.

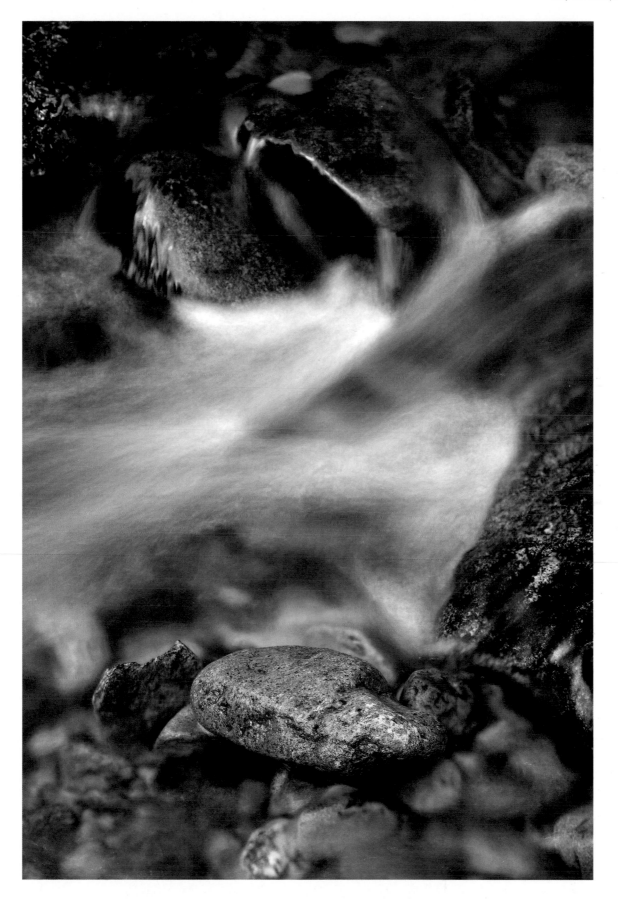

How do your pictures work?

Do you want your pictures to be a purely visual record for the viewer or would you like them to cause a reaction and generate a response?

p49 Aira Beck
Cumbria, England
Clive Minnitt

p51 Valensole Plateau
Provence, France
Clive Minnitt

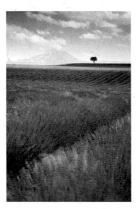

p49

p51

Inspiration: There are occasions when I'm inspired for no other reason than the scene simply hits the right spot – pictorially speaking.
The situation: Aira Beck is a fast-flowing stream which forms picturesque Aira Force waterfall before cascading down the hillside into Ullswater. Having chosen my viewpoint, my options were to either use a faster shutter speed (increasing the ISO such that the movement of the water was 'frozen') or to create an impression of movement with a slower shutter speed. This time I plumped for the latter.
Camerawork: Camera: Canon EOS 5D
Lens: Canon 24-105mm f/4L IS USM at 105mm
Exposure: 1.3 seconds at f20
Filtration: Polariser
Other: Minus 1/3 exposure compensation, ISO 50

I spent some time deciding how to compose the image around the single rock in the foreground. It would also make a pleasing square image, if all the rocks at the top were omitted. **CM**

I wouldn't crop this image to a square as I think the rocks at the top of the frame add solidity to the image. I also love the way they are lit along their edges, their textures being smoothed by the cascading water. For me, one key element is the small area of red to the right of the foreground stone. **PM**

Inspiration: An exercise in waiting for the magical moment, keeping fingers crossed that it would actually happen.
The situation: When there are so many different things going on in front of you, it is easy to get confused and miss the picture altogether. Studying this image makes me realise how many decisions I had to make regarding composition, never mind metering the light. Proportion of sky to land? Placing of the tree and mountain? What angle to have the rows of lavender? Can I get the clouds and lavender to form a relationship? Do the clouds sit comfortably with the mountain? When will the clouds be in the optimum position? If I wait any longer might it get even better? What lens should I use? If I fire the shutter when the wind blows what will be the effect? Do I need a slower shutter speed to generate more movement? If so, how do I achieve a slower shutter speed? Do I want it all in focus or some of it?
Camerawork: Camera: Canon EOS 5D
Lens: Canon 24-105mm f/4L IS USM at 82mm
Exposure: ISO 50, 3.2 seconds at f20
Filtration: 0.6 ND hard graduated, 0.6 neutral density, polariser
Other: Plus 2/3 exposure compensation

Sometimes, no matter how much we plan, anticipate or pre-visualise the final image, it doesn't come together. When the sun poked its head through a gap in the clouds and cast a single ray of light across the lavender field at precisely the same time as the wind gusted, it was the icing on the cake. **CM**

It is clear to see from his notes how hard Clive worked here. We can all learn from this. He wasn't prepared to accept what was immediately in front of him. A stunning image of a wonderful location. **PM**

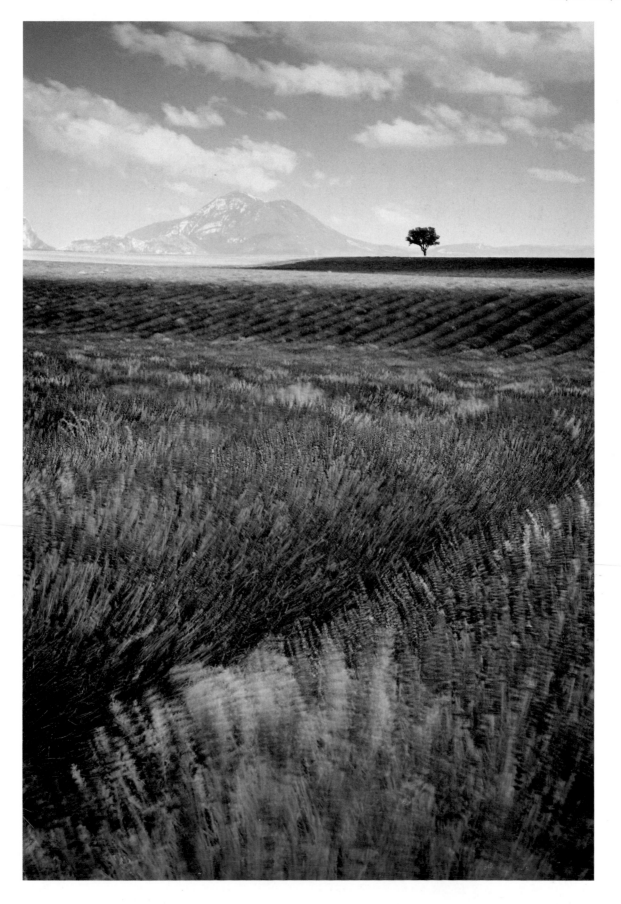

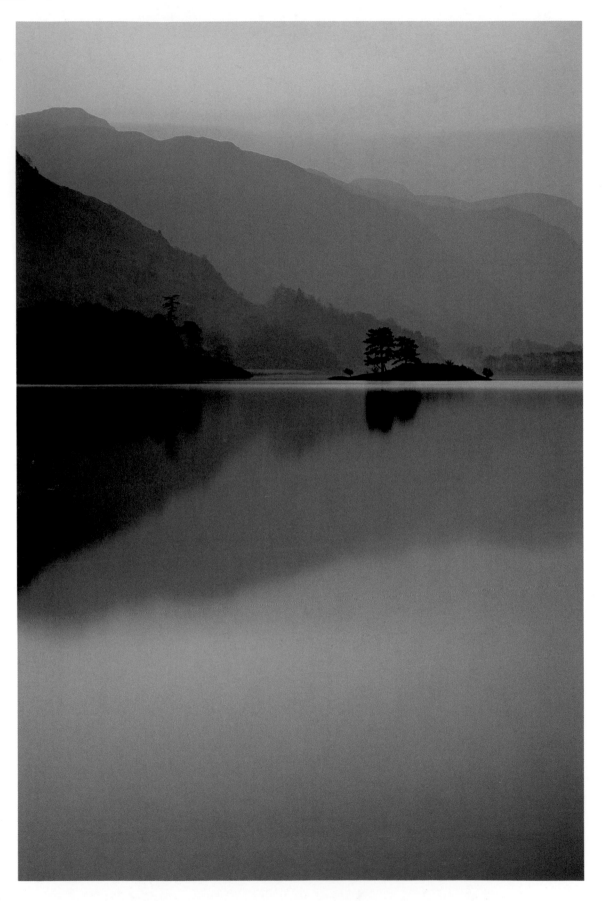

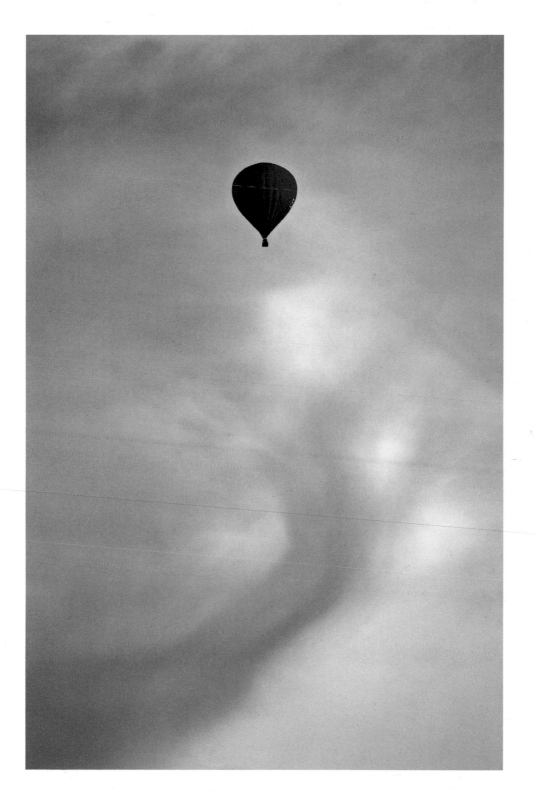

Positive tension
Tension in a picture can be a good thing, if your aim is to unsettle and provoke the viewer into a reaction.

Confidence has to be worked at

Those who succeed at something aren't always the most confident people, but those who are the most committed to finding success.

p52 Ullswater
The Lake District, England

Phil Malpas

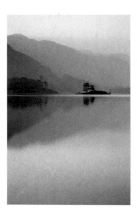

p52

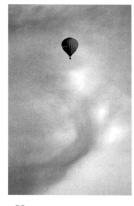

p53

Inspiration: Many visits to the Lake District have taught me that perfect still dawns such as this are far from common. When conditions are right, we are lucky in the UK to have such world-class scenery on our doorstep.

The situation: On our way out at dawn during a photographic tour in 2009, it soon became clear that our intended location was blanketed in fog. A swift return to Ullswater rewarded us with perfect still conditions and a photographic feeding frenzy ensued.

Camerawork: Camera: Canon EOS 1DS MkIII
Lens: Canon EF 100-400mm f/4.5-5.6 L IS USM at 100mm
Exposure: 120 seconds at f10
Filtration: 3.0 neutral density
Other: ISO 50

The 10 stop ND filter has allowed a two minute exposure and added a small amount of false colour to the captured image. I really like the recession caused by the hazy atmospherics and also the fact that the small island is the darkest element in the composition. **PM**

Knowing the Lake District so well, Phil is able to relate to the subject. Being able to adapt to changeable weather conditions is one of the tasks a tour leader is often called upon to do. As an alternative location this one couldn't have been better. This scene is so tranquil; pastel light is a perfect match for the calm conditions. Where to position the small island was the big question. Answer – exactly where it is, so that it sits comfortably under the sloping hillside behind it. **CM**

p53 International Hot-Air Balloon Fiesta
Bristol, England

Clive Minnitt

Inspiration: Each year a group of photographers, amateur and professional, visit the fiesta and produce excellent images. It's on my doorstep and, as a result, I keep putting off my own attempt at documenting the event. This is my attempt to produce an image that is a little different from the norm.

The situation: The wind direction was important – a light, easterly breeze took the balloons across the city and within my range. I had positioned myself on the approach to the Clifton Suspension Bridge, which turned out to be a rather fortuitous move.

Camerawork: Camera: Canon EOS 5D
Lens: Canon 100-400mm f/4.5-5.6L IS USM at 320mm
Exposure: 1/60 second at f14
Filtration: Polariser
Other: Hand-held using image stabiliser, plus 1/3 exposure compensation, ISO 400

A simple and uncluttered image. The vertical cloud worked in my favour and I excluded other balloons nearby, which would have over-complicated the scene. Space is crucial to this image – in more ways than one. **CM**

The power in this image, for me, is the simple fact that the balloon is red and that it occupies such a small part of the frame. Of course, the curved gap in the clouds is spectacular. You can almost imagine that the balloon has caused it on its journey through the heavens. **PM**

On location:
The Outback

We landed on a barbed wire fence! Quite how the pilot managed it I'll never know as we were miles from anywhere in the middle of the Australian Outback. There was nothing else on which to land the darn thing!

My pulse rate increased within seconds of booking this flight over the inhospitable terrain, and the chance to photograph the balloons in this harsh environment was too good to miss. Travel, hot-air balloons and photography – was I dreaming? I had become passionate about hot-air ballooning whilst living in Bristol, the ballooning capital of England, where balloons are regularly seen flying over the city in their various colours, shapes and sizes, and I had made several flights in the past.

The pilot ignited the burner and we were soaring above the desert in rapid time. Although the light was wonderful the potential to shoot high-quality images of the scenes below didn't meet my expectations. The land appeared two-dimensional with very few distinguishing features on which to train my lens. It was almost devoid of shadows. I was disappointed to say the least but didn't give up hope that the opportunity to create a great image would present itself at some stage.

My spirits rose when I noticed that the two other balloons in our aerial convoy were slightly higher than us. I reckoned that if the bright red and yellow balloons maintained this relationship for the entire flight, I should be able to photograph them against the rich blue sky *and* include a sliver of desert just after we landed.

For a moment, luck was on my side; as we descended a series of wispy cirrus clouds formed, perfectly positioned alongside the other balloons. Then, the intimidating barbed wire fence loomed; there was no wind to enable the pilot to divert to safer ground. I had no time to dwell on the potential consequences and tried to ignore the pandemonium as I leapt out of the basket, camera and lens already primed for the shot.

Got it! How ironic that the decisive moment came when I was on terra firma! But my prior knowledge of ballooning was invaluable and enabled me to anticipate the pilot's manoeuvres so that I could capture the image I wanted successfully. **CM**

Learning from mistakes
We all make mistakes. They are part of the learning process and an invaluable way of improving our skills. For example, an underexposed picture might produce a lovely low-key result and prompt ideas for photographing other subjects in the same way.

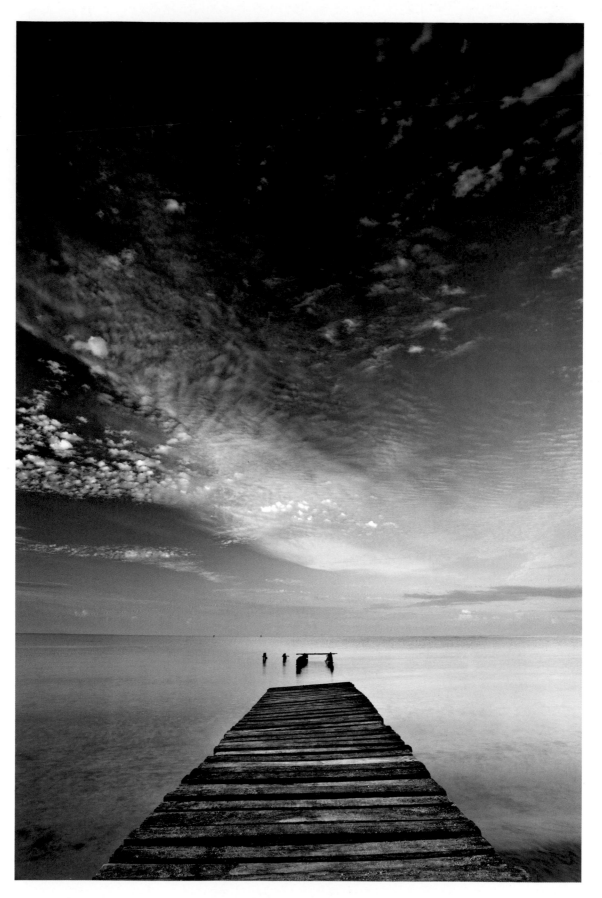

Capturing the moment

Photography is unique amongst the creative arts for two main reasons. It allows us to effectively stop time, to capture any particular instant and freeze it forever, and to return to that instant at our leisure. For this reason it has become an essential means of recording special occasions. Weddings, children's birthdays, graduation ceremonies, family holidays and so on are all captured so that we can recall these significant moments in our lives and share them with others.

If we are to improve the quality of the images we make, it is important to recognise that while there are an infinite number of opportunities to press the shutter button, only a small number of these will deliver a memorable result. Landscape photographer David Ward is a champion of the idea of 'slow photography' as a way to improve. This isn't to do with using slow shutter speeds but relates to the amount of time we invest in any particular image. In today's digital world it is easy to fall into the trap of 'shooting from the hip', to adopt the scattergun approach of taking hundreds of images in the hope of getting a few good ones. Instead, David advises us to slow down, to immerse ourselves in our subject, to take the time to study it in minute detail and then to capture that decisive moment through planning and preparation rather than pure luck.

The second unique aspect of photography *does* in fact relate to using slow shutter speeds. As well as capturing a particular instant, photography allows us to record a longer period of time in one image, through the use of extended exposures. This is something we often take for granted, but it is fundamental to our understanding of what we are trying to create. Of course, in the majority of cases, our images will be made in a fraction of a second. To all intents and purposes they capture a specific moment in time. When light levels are low, however, or by using filtration to limit the amount of light entering the camera, we can capture a single image over many minutes or even hours. This opens up a whole new creative world that only we photographers can access. **PM**

The effect of changing light

With your camera on a tripod, photograph the same scene a dozen times throughout the same day, and analyse which image works best and why. Is it the quality of light that makes all the difference: its angle or changing mood and the way that it affects our interpretation of the location?

It's all a learning process

How much do you need to know to find a picture and make a great image of it?
Perhaps your approach to photography is the greatest barrier to your own success.

p56 Caribbean Sea
Cienfuegos, Cuba

Phil Malpas

p56

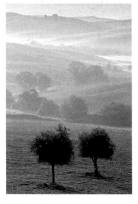

p59

Inspiration: 'The abandoned jetty is one of my favourite photographic subjects. A colleague once declared that this would be a great image to use for a postcard ending a relationship – long walk off a short pier and all that.

The situation: I arrived here in almost complete darkness, but the jetty was partially lit by a nearby electric spotlight. I enjoyed balancing the artificial and natural light as night changed to day.

Camerawork: Camera: Canon EOS 5D
Lens: Canon EF 17-40mm f/4L USM at 21mm
Exposure: 0.8 seconds at f18
Filtration: 0.6 ND hard graduated, polariser
Other: ISO 50

I really like the feeling of peace and tranquility that I get from this image. The polariser has had an extreme effect at the top of the frame and I have, on occasion, used this image as a cropped square from the bottom upwards to remove this. Sadly this approach also removes some of the lovely cloud formations. **PM**

A wonderful sky, one to savour. As cloud formations change so rapidly Phil would have had to work quickly to get the composition he wanted. His major decision would have been what ratio of sea to sky? The sky is a little on the dark side – it is very easy to overdo the use of a polariser filter. The twists in the boards confirm the jetty's abandoned state. A very powerful and atmospheric picture, which has been photographed in stunning light and was worth the effort of getting out of bed early. **CM**

p59 Val D'Orcia
Tuscany, Italy

Phil Malpas

Inspiration: For me the rolling Tuscan hills, particularly in the La Crete region, are at their best in early spring. The lush, verdant greens are often accompanied by mist that swirls through the valleys, making the landscape highly dynamic.

The situation: The image was taken just after sunrise, shooting almost directly into the light. I used the two small trees to provide a strong foreground for the view along the meandering valley behind.

Camerawork: Camera: Canon EOS 1DS MKIII
Lens: Canon EF 100-400 f/4.5-5.6 L IS USM at 150mm
Exposure: 1/13 second at f18
Filtration: 0.3 ND hard graduated
Other: ISO 50

I like the way the valley leads the eye through the image to the small farmhouse at the top of the frame. My main decision was how much of a gap should I have between the two trees? I walked left and right many times before selecting this spot as my favourite. **PM**

This was a testing scene in terms of composition as there are so many elements to deal with. Excluding the sky, which would have been devoid of detail, was the right decision. Space between, and above, the two foreground trees, is crucial to the success of the image. Another key factor is timing. An early start gave Phil every chance of capturing the mist that gives the Val d'Orcia such a magical look. Late risers missed this special, atmospheric treat, but Phil has definitely captured the moment. **CM**

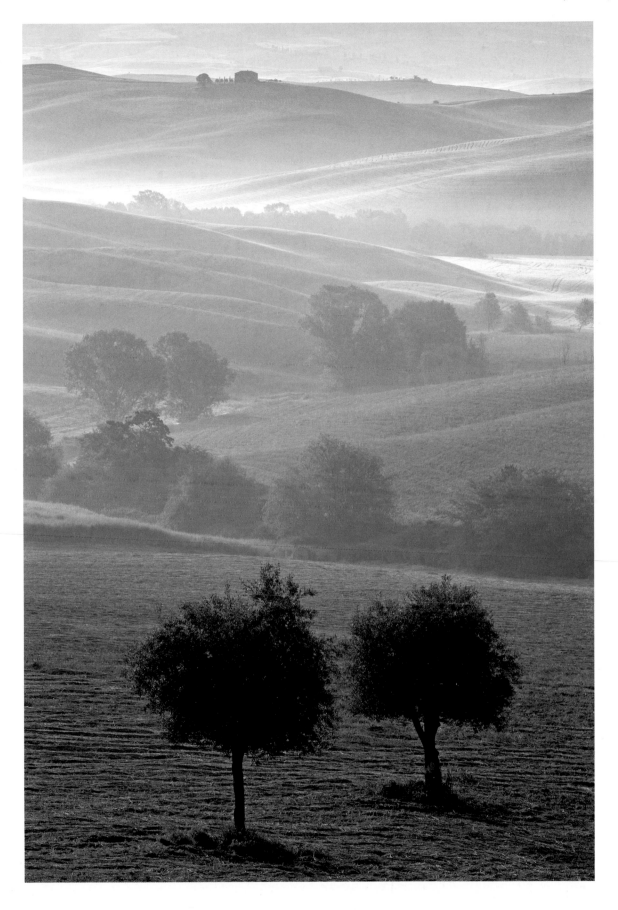

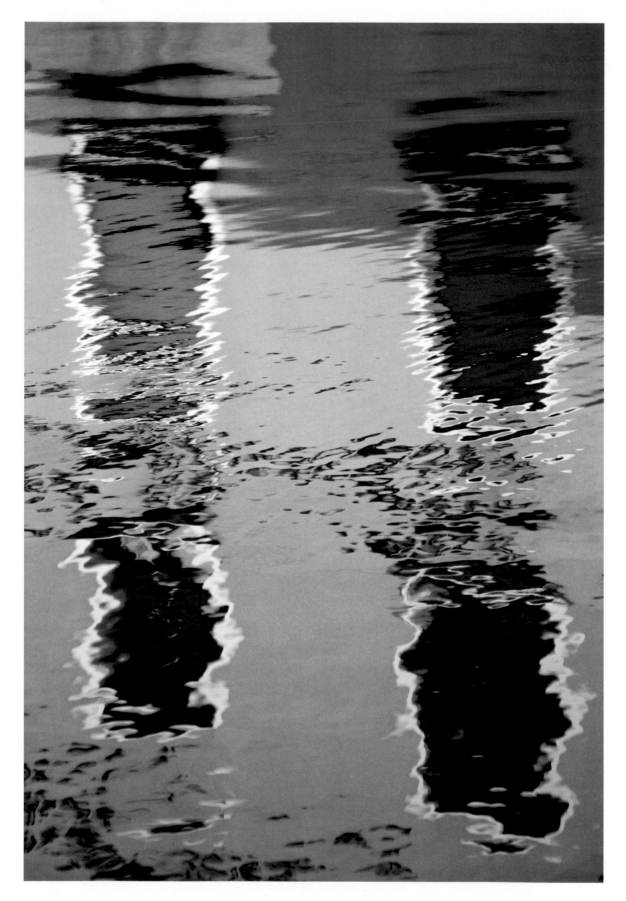

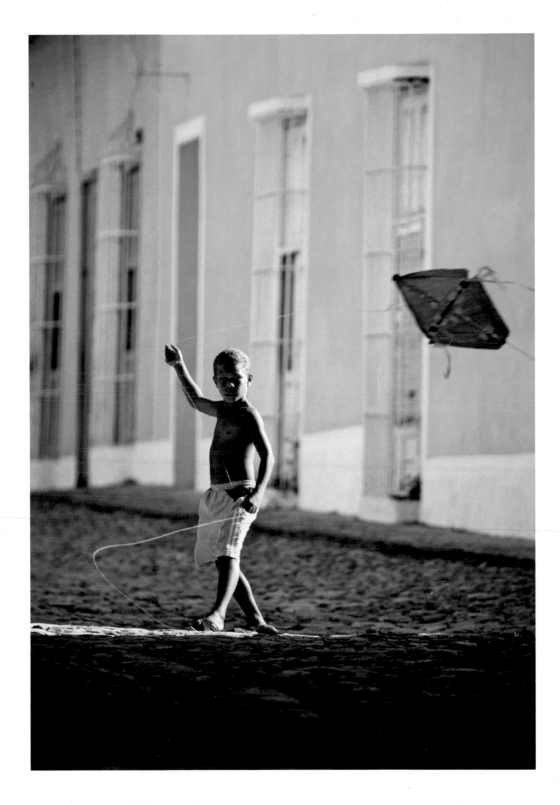

Urban light

*When visiting towns and villages, note which side of the
street will be in the sun or the shade at any given time.*

Changing light

Visiting a location in the morning and again later in the day will offer a dramatically different variety of picture-making opportunities as the angle of light shifts.

p60 Bacino Orseolo
Venice, Italy

Phil Malpas

p61 Trinidad
Cuba

Phil Malpas

p60

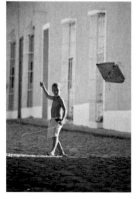

p61

Inspiration: Venice is a great place to photograph reflections as the water in the canals is usually still due to their sheltered aspect. This particular image is all about colour and making sure that the palette was limited to just red, yellow and white.
The situation: The Bacino Orseolo is used as a mooring for gondolas and is a great place to photograph these iconic watercraft. In this image I concentrated on the reflections of the brightly coloured Cavaletto Hotel.
Camerawork: Camera: Canon EOS 10D
Lens: Canon EF 28-135mm f/3.5-5.6 IS USM at 109mm
Exposure: 1/250 second at f5.6
Filtration: None
Other: ISO 100

I find the white area in the top left of the frame distracting, but there was nothing that could be done to avoid having it in the frame. There was quite a surprising ripple on the water and I think the fast shutter speed has stopped the image from becoming too abstract. **PM**

My imagination has been sparked by this image, which is full of mystery and intrigue. The white area isn't an issue for me – if it was a solid block it probably would be. It is also muted by the shade at the top of the image. Several darker areas in the water are well placed between the shutters, which must have been quite a challenge. **CM**

Inspiration: Clive was busily photographing a nearby number plate that had his name on it, and whilst I was waiting for him, I spotted this small boy playing about 60 yards away. I knew I had to try to photograph him.
The situation: The boy was running up and down the street. I needed him to be in the small area of side-lighting, with his kite in the frame and no passers-by in the background. It took me about twenty minutes and many attempts before I captured what I had visualised.
Camerawork: Camera: Canon EOS 5D
Lens: Canon EF 100-400mm f/4.5-5.6 L IS USM at 400mm
Exposure: 1/200 second at f5.6
Filtration: None
Other: ISO 50

We sometimes have an attachment to images that are hard to achieve, which may not relate to their actual success. I can't help liking this image, though. It took a lot of time and effort, but everything fell in to place for that one split-second and I was able to take my chance. **PM**

I love this image – I know how hard Phil worked for it. It records a single moment in the boy's life, and through perseverance and being able to imagine the end result he was able to create a great picture, pressing the shutter at precisely the right moment. **CM**

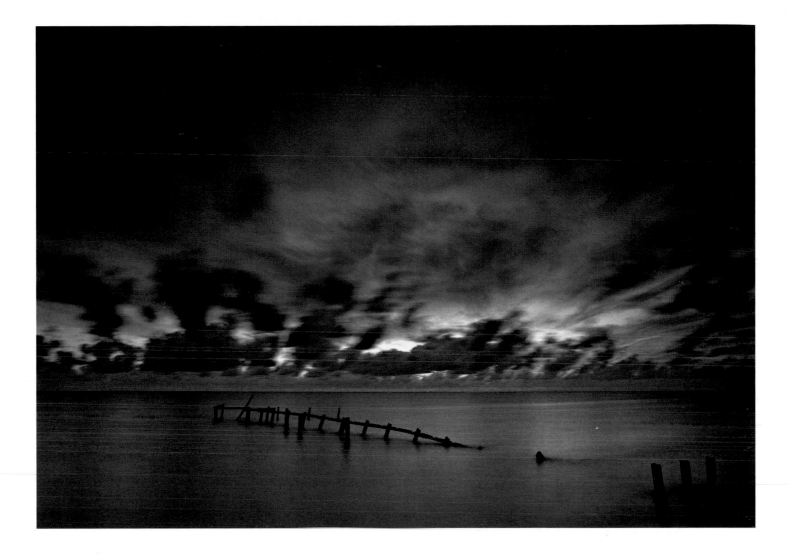

Colour filtration

If shooting RAW, overall colour temperature adjustments can be made during the RAW conversion process. However, if you shoot in jpeg mode, then overall colour temperature adjustments are usually best made in-camera.

Crop before you shoot

Cast your eye around the edges of the viewfinder twice before pressing the shutter release and crop out any superfluous items at the picture-taking stage.

p63 Caribbean Sea
Trinidad Del Mar, Cuba

Phil Malpas

p65 Restaurant at a vineyard near Oia
Santorini

Clive Minnitt

p63

p65

Inspiration: When nature puts on a display like this, it is simply a case of finding something interesting to place in the foreground.

The situation: On arrival at Trinidad del Mar, I was keen on a few minutes sleep before dinner, but Clive insisted on dragging me out for a look around. Luckily he spotted this derelict jetty about 400 yards along the beach and we were able to use it as a foreground for this fantastic sunset.

Camerawork: Camera: Canon EOS 5D
Lens: Canon EF 17-40mm f/4L USM at 24mm
Exposure: 30 seconds at f20
Filtration: 0.6 ND hard graduated, 0.9 ND, polariser
Other: ISO 50

The clouds were moving fairly quickly and I was aware that I could saturate the apparent colour and give a feeling of movement by using a long shutter speed. The polariser and ND filter also helped the composition by smoothing out any movement in the water. **PM**

When you see light like this developing it is worth going the extra mile (or 400 yards in this case) to find a foreground that adds that extra special ingredient. Phil and I were giving it 'high fives', having seen the most fantastic dusk sky in a long time. A memorable evening and a very atmospheric picture which truly reflects the mood at the time. **CM**

Inspiration: After a glass of the local red wine anything was possible! The light was what first caught my attention – as it so often does.

The situation: The strong midday light was diffused by the latticed roof. I chose my angle carefully so that the light falling on the foreground table pointed to a similar effect on the chairs behind. The bowl and the vase of red flowers were very strong subjects and I had to compose the image in such a way that they didn't compete for the viewer's attention. One other consideration – as the position of the sun changed, it affected the angle of light falling on the furniture. I had to work quickly.

Camerawork: Camera: Canon EOS 5D
Lens: Canon 24-105mm f/4L IS USM at 60mm
Exposure: 1/125 second at f5.6
Filtration: Minus 1.0 exposure compensation
Other: 0.9 ND hard graduated, ISO 50

The neutral density filter was placed upside-down so that it covered the whole of the table and bowl of flowers. This helped to reduce the contrast to a workable level. The decision to use a wide aperture to reduce the depth of focus means the viewer has to use their imagination. **CM**

Clive exhibits his intimate knowledge of contrast management here. The selection of a 3 stop ND grad may not have occurred to everyone and yet it was needed to ensure balance between foreground and background. **PM**

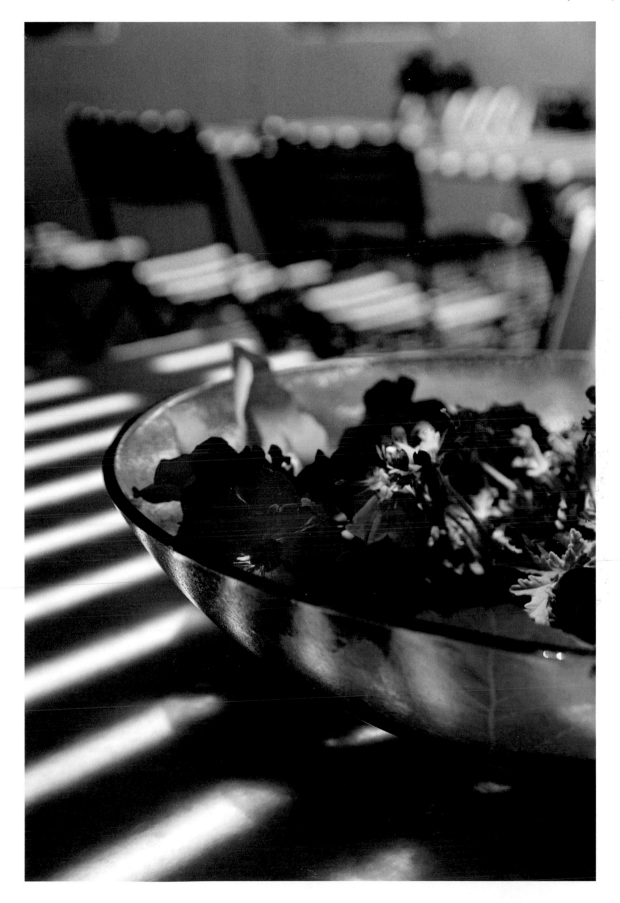

Expressing ourselves

For many people their photographic journey begins with a desire to immerse themselves in image-making technology. Their shiny new camera comes with its 300 page manual and the photography magazines bombard them with techniques-based articles on subjects such as how to master photo editing software. Even worse, they are suddenly required to learn a whole new language made up of unfathomable three-letter abbreviations (TLAs).

Of course, it is important that we read our camera manuals and understand the creative potential that technology can offer us, but many modern cameras offer a host of settings that we are unlikely to ever want or need. Some people never progress beyond this point. We've all met them. They know the ins and outs of pixels, colour filter arrays, analogue to digital convertors, and are lost in a never-ending quest for ever-improving technology.

In truth some of the greatest photographic images ever made were achieved with what we would now consider to be outdated technology. We should never forget that it is the photographer that takes the picture and that the camera is just a tool. It is important that as photographers we allow our creative side to rule the technology, not the other way around.

At a recent photographic event, Joe Cornish gave a fantastic piece of advice. He said 'Get out more and take fewer pictures.' We need to try to ignore the technology and practise the creative side of photography. We don't even need a camera to do this. Wherever you are and whatever you are doing you can constantly learn how the world around you might be distilled into an exciting image. How foregrounds and backgrounds relate, how colours, shapes and textures combine, and most importantly, how light illuminates a scene or subject.

Another way to nurture your creative side is to try to understand what appeals to you in your favourite images. Develop your own view of what makes a great image, and when you are out with your camera don't settle for second best. Always strive for creative perfection and don't be afraid to press the delete button! **PM**

Excessive contrast
There are several ways of reducing excessive contrast. The traditional method is in-camera, with ND graduated filters or waiting for the light to change. Now there are also HDR (high dynamic range) techniques. These employ two or three different exposures of exactly the same scene (with the camera on a tripod), which are combined to bring out shadow detail and retain highlight values.

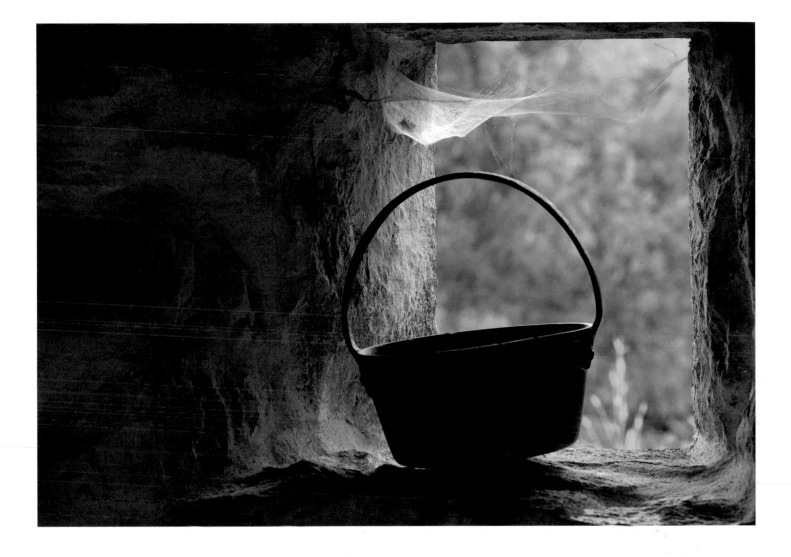

Use focus creatively
Changing the proportion of an image that is in focus can radically alter the mood of a composition. Practise by taking a series of shots, each focused on the same point, using a different aperture for each one. Which image works best and why?

Less is more

Our instincts often tell us to include too much in our compositions. The wide-angle view is one of the most difficult to make meaningful, as it can include everything but say nothing.

p67 Brouelles, near Cahors
The Lot, France
Clive Minnitt

p69 Oia, Santorini
Cyclades Islands, Greece
Clive Minnitt

p67

p69

Inspiration: A week spent holidaying with friends in the Lot was a fun and relaxing time. There was no pressure to photograph but within minutes of arriving I was buzzing at the thought of capturing this on my camera's sensor.
The situation: A simple, uncluttered scene on the face of it but it proved to be a difficult one to capture. I waited several days before the light was suited to the task. Luckily, I was staying in the building and didn't have far to travel.
Camerawork:
Camera: Canon EOS 5D
Lens: Canon 100-400mm f/4.5-5.6L IS USM at 150mm
Exposure: 1.6 seconds at f13
Filtration: 0.6 ND hard graduated
Other: Minus 2/3 exposure compensation, ISO 50

The final result is how I imagined it. The wait for the best light was justified. **CM**

The light on the cobweb is absolutely crucial to the success of this image. Clive's experience allowed him to imagine the possibility of this image and then wait for the conditions to deliver. Conditions have also allowed him to cleverly manage the contrast range which would have been problematic in brighter light. **PM**

Inspiration: The volcanic archipelago of Santorini is a spectacular location for photography. Finding new ways of photographing familiar and well-documented subjects is both challenging and rewarding
The situation: White cliff-top dwellings, picturesque chapels galore and a precarious 900ft drop to the sea
Camerawork: Camera: Canon EOS 5D
Lens: Canon 100-400mm f/4.5-5.6L IS USM at 400mm
Exposure: 1/5 second at f14
Filtration: None
Other: Minus 1/3 exposure compensation, ISO 50

The juxtaposition of foreground and background elements works well. Electing to render the bell and tower out of focus cunningly disguises any flaws in the structure. **CM**

It is important to fully understand the relationship between focal length, aperture and depth of field. Clive has selected the aperture with great care to render the foreground exactly as was needed to ensure that it was still understandable and yet not distracting. The intense blue of the ocean is stunning and the inclusion of the far coastline gives depth to the composition. **PM**

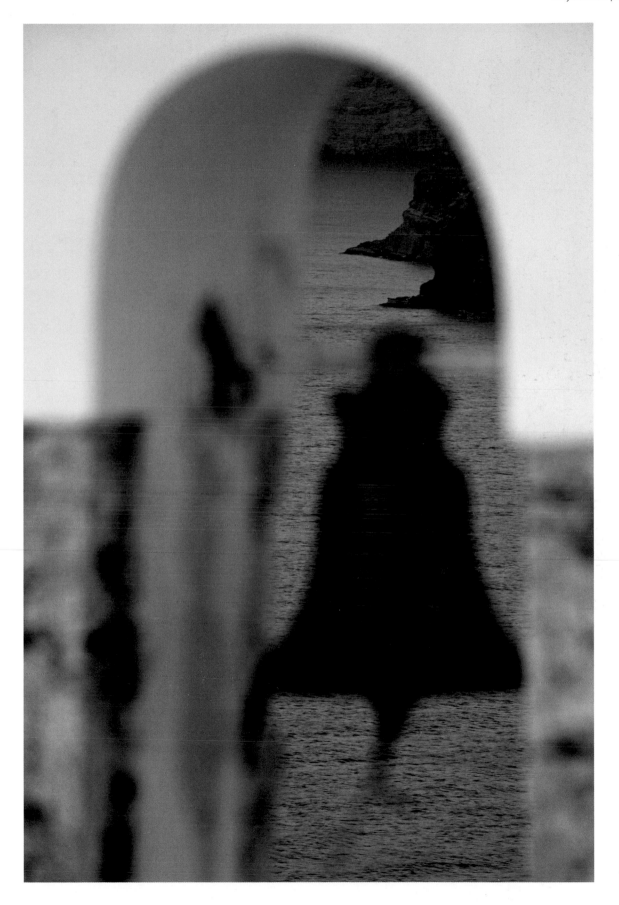

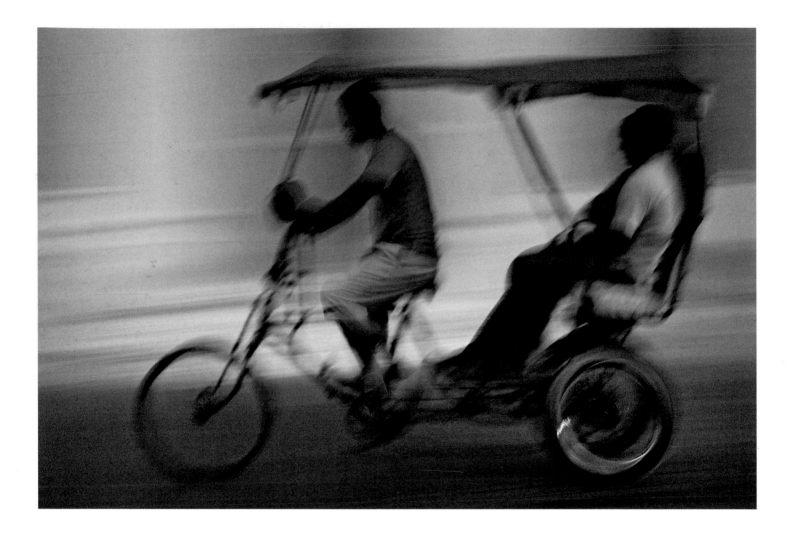

Be prepared
Both the weather and subject matter can change in an instant.
Those who are not prepared may miss the picture of a lifetime.
The ones we miss are usually those we remember longest.

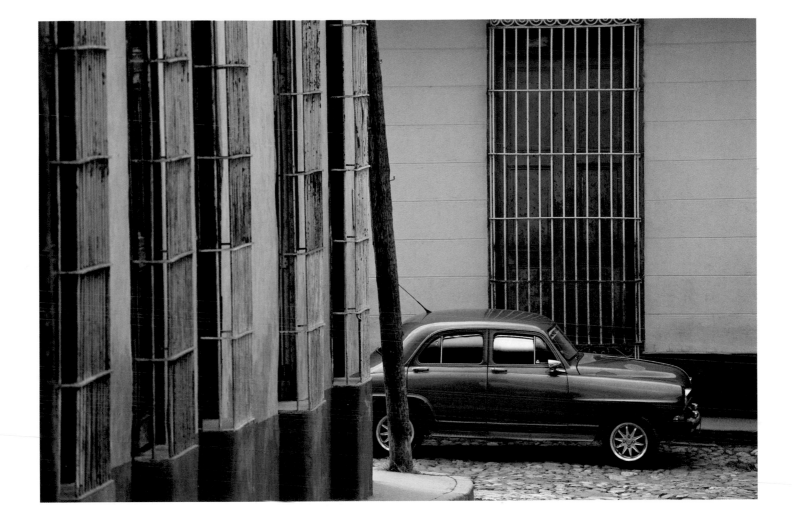

Let go of control
*Invite your peers to set you a photographic challenge. For example,
you might ask them to suggest a number of subjects to photograph.
Ask them for feedback on the results and learn from their input.*

Familiarity breeds contempt
Always try to look at everyday scenes and objects in a different light. Your garden is an excellent starting point.

p70 **Havana**
Cuba
Clive Minnitt

p71 **Trinidad**
Province of Sancti Spíritus, Cuba
Clive Minnitt

p70

p71

Inspiration: It is not difficult to be inspired in Havana – just take plenty of film and/or digital storage and everything else will come to you.

The situation: I was prepared, having observed two similar forms of transport 'speed' past moments earlier, but had to adjust my position so my view was not blocked by trees and pillars.

Camerawork:
Camera: Canon EOS 5D
Lens: Canon 100-400mm f/4.5-5.6L IS USM at 100mm
Exposure: 1/5 second at f7.1
Filtration: None
Other: Hand-held using image stabilizer, minus 1 exposure compensation, ISO 1600

The high ISO concerned me initially, as it produces too much 'noise'. The panning action helped to disguise the noise and has improved the atmospheric 'feel' of the image. Ideally, I wanted a 1/30 sec shutter speed but there wasn't enough ambient light to generate it. **CM**

Clive and I have spent many happy hours working with panning in Cuba and this is one of the most pleasing results either of us has come up with. The image stabilizer on his lens can be set to work in only one direction, which is a useful tool. This image is full of excitement. It makes me want to know more. Who are these people? Where are they going? What is in store for them at the end of their journey? **PM**

Inspiration: Some of the colour combinations of the cars and buildings in Cuba are extraordinary. I would challenge anyone with an interest in photography not to be inspired to get their camera out.

The situation: You are never far from the sound of Cuban music or the bright colours of regularly restored cars. Ambling around Trinidad is a delight. Smiling faces greet you and an invitation to share a lobster with a local family is never far away. I prefer exploring quiet back streets to the busier tourist areas. Re-visiting families to deliver a gift of a photograph I had taken of them the previous year was one of the highlights of the tour. It was unforgettable.

Camerawork: Camera: Canon EOS 5D
Lens: Canon 100-400mm f/4.5-5.6L IS USM at 320mm
Exposure: 1/250 second at f9
Filtration: None
Other: Hand-held using image stabilizer, ISO 200

I would have preferred an older-looking car, but perhaps that's nit-picking. The colour combination is wonderful. **CM**

I was with Clive when he made this photograph and I elected to crop tightly in on the car itself. I think his image works better as it places the car in the context of its surroundings and shows off the spectacular paint job to a greater degree. I really like the way the front and rear windows of the car are reflecting the different colours around them. **PM**

On location:
Santorini

I have fallen in love with Santorini, the southernmost island of the Greek Cyclades. In reality it is a series of islands which once formed a single volcano. A huge eruption split the volcano into several pieces, sinking the central cone. Further volcanic activity and earthquakes have sculpted Santorini into a magnificent steep-sided caldera filled with seawater. An active crater persists on the small island of Nea Kameni in the centre of the caldera.

Picturesque white chapels topped with rich blue domes cover the island; a mix of colourful and white traditional houses appear to drip down the edge of the nine hundred foot sheer drop into the blue sea, which itself is as deep as the cliffs are high. The inevitable cruise ships, large as they are, create a vision of toy boats bobbing in the bathwater as they gently steam into the caldera.

Dedicated landscape photographers and flocks of tourists do not generally mix. Visitors from many nations clamber onto any available vantage point to watch the sun disappear below the horizon. Who were we to wish they weren't there? They were probably willing our tripod legs to recoil in haste! One couldn't help but be seduced by the good humour and the air of expectancy. The atmosphere was electric. A group of Japanese girls giggled non-stop as they looked at the LCD on the rear of my camera. Each of them, in turn, then entrusted me with their camera, urging me to take their team photo.

A few wispy clouds appeared and were given a nod of approval by the rest of my group, making my job even more satisfying. As the throng launched into a passionate round of applause the moment the sun made its final bow, I turned to Paul Harris (my course co-leader) and whispered, 'Just watch this, it will be almost deserted within five minutes.' And it was – we were in business!

The gorgeous, whitewashed buildings were bathed in an afterglow; lights illuminated the steep steps and paths along the hillside whilst buildings were lit from within. The sky was a magical myriad of orange, red, yellow and mauve, and two windmills stood proudly above the horizon, inviting our lenses closer. It had the wow! factor and we had a bonanza. Fun or what? **CM**

Know your strengths and weaknesses

Identify your strengths and use them to focus on producing your best work. For example, you might discover you are skilled at creating artistic photographs of wild flowers in the landscape, which might be as a result of having a passion for all things floral. Persevering to improve your photography of subjects in which you are less interested or proficient will help you to learn new techniques.

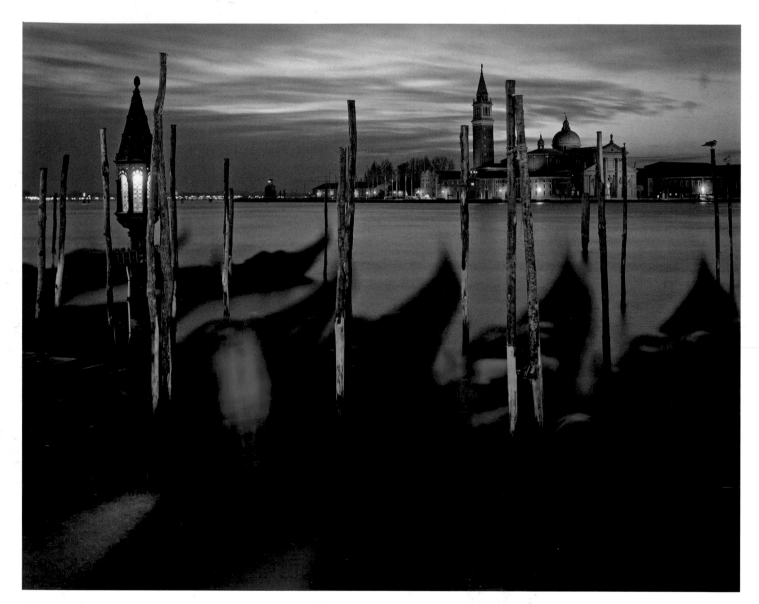

San Marco, Venice, Italy. **PM**

Have a break!
Having a break from photography may not seem like a logical thing to do, but it's always useful to devote some time to assessing your work and exploring other sources of inspiration – such as bookshops, galleries and photographers' websites.

Where do our ideas come from?

Working with others | On location: The Coigach Peninsular | Imagination | Developing your vision | On location: In Venice with Charlie Waite

When leading photographic workshops, we always begin by asking the attendees what they hope to get out of the course. The most common answer photographers give is that they need help with composition. Of course, we are more than happy to offer this to them, but in reality there is no magic solution, no right or wrong way to design our images.

We are all influenced by images that inspire us and we understandably try to emulate photographers who we perceive to be experts at image making. This is healthy, and isn't motivated by a desire to copy, but by a wish to learn from the masters of the art. Typically we take different elements from a variety of sources and use them in an effort to make better images of our own. All these elements will provide a subliminal input when we are working with our cameras.

Poor composition usually arises from lack of care and attention, a willingness to accept the first thing we see. A far better approach is to start by leaving the camera in the bag. You don't need it to find your viewpoint. Just allow yourself to 'be' in a location, consider your options and allow your own influences to drive you. **PM**

Working with others

Let your imagination wander

Arriving at a new location with a group of photographers can be daunting, especially if some of the others get to work within seconds of arriving. Don't panic; this doesn't mean their pictures are going to be superior to yours and they may simply be going for the obvious shots.

It is amazing how a group of photographers with similar equipment, in the same location, at the same time, in identical conditions can produce such a variety of images. The tripod legs might be almost interlocking but the precise framing, focal length, filtration, aperture and shutter speed all contribute to ensure that no two images are ever the same.

We all see the world differently and the sooner we accept this, the closer we will be to developing our own vision and style. Working with other photographers may not be something you want to do all the time, but it can be highly instructive. It is likely that someone in a group will see something or adopt an approach that hadn't occurred to you. In return your ideas can inform others. All this interaction serves to increase your store of photographic ammunition for future use.

For the past three years, David Ward and I have run a Winter in Glencoe tour, which is designed to be an Intensive Landscape Technique Workshop. These tours run in January and as such the daylight hours are limited. Consequently there is plenty of time in the evenings during which we use a digital projector to review the pictures that clients have made each day. This is a fantastic learning experience, for everyone present. It is fascinating how lengthy debates can ensue about a single image, how people's opinions differ so widely and how often the question 'Where did you see that?' arises. Of course, the many superb images shown in these sessions are suitably praised and applauded, but all those present who didn't make those images can ask themselves why they missed the opportunity that was so obviously available.

The other advantage of working with fellow photographers, whether they are a group of friends, a photographic society or an organised tour, is that they understand that our obsession is not something to be taken lightly. Photography takes time, contemplation, consideration, and simply cannot be rushed. **PM**

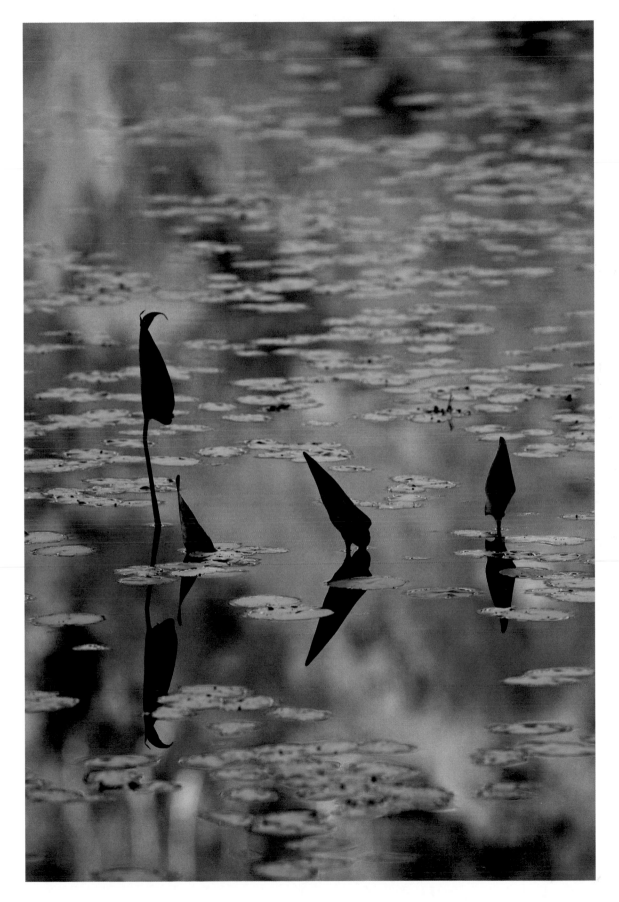

Revisit locations
It would be difficult to exhaust the picture possibilities at any location in a single visit.

p77 Bailey Pond
near Marshfield, Vermont, USA
Clive Minnitt

p79 The Cobb
Lyme Regis, England
Phil Malpas

p77

p79

Inspiration: There were so many possibilities here that it was difficult to see the wood for the trees. Careful selection of subject matter was necessary as was being aware of any unwanted details creeping into the edge of the frame.
The situation: Still conditions and excellent reflections; spectacular colours under a clear blue sky. As the foreground was in the shade, the light was perfect.
Camerawork: Camera: Canon EOS 5D
Lens: Canon 100-400mm f/4.5-5.6L IS USM at 350mm
Exposure: 1/8 second at f10
Filtration: None
Other: ISO 50

I selected a suitable aperture which meant that the background, sunlit forest would be out of focus. Crucially, I had to position the four protruding leaves so that none of their reflections overlapped the others. As David Ward so often says, I had to create order out of chaos. The leaves on the water's surface reflected the blue of the clear sky rather well. **CM**

This has been a very productive location for us during our Light & Land trips to Vermont. The richness of the fall colour here is amazing and faced with an immensely complex scene, Clive has distilled simplicity from it. Perhaps I might be tempted to remove the single blue leaf in the bottom left of the frame to give a more balanced base to the image. **PM**

Inspiration: I am a big fan of the work of Michael Kenna and I had seen his amazing image of The Cobb on his website. As I was in the area I decided to try and create my own version.
The situation: I was staying about 20 miles away, and being early summer it was necessary for me to get up at 4:30 am to reach the location in time for sunrise. I managed to make it five days out of the seven I was there and this was taken on the best day!
Camerawork: Camera: Canon EOS 5D
Lens: Canon EF 17-40mm f/4L USM at 17mm
Exposure: 1 second at f22
Filtration: 0.6 ND hard graduated
Other: ISO 50

The distortion caused by the wide-angle lens is slightly annoying, but I love the extreme depth of field and the sharpness of the structure in the foreground. **PM**

We are all inspired by the work of others. Role models are important for us to learn new techniques and ideas. They also enable us to assess how we are progressing with our own photography. I'm impressed with Phil's determination to capture the shot he had in mind. Lovely use of dawn light. The gap between the end of The Cobb and the distant headland is very important as it creates a greater 3D effect. **CM**

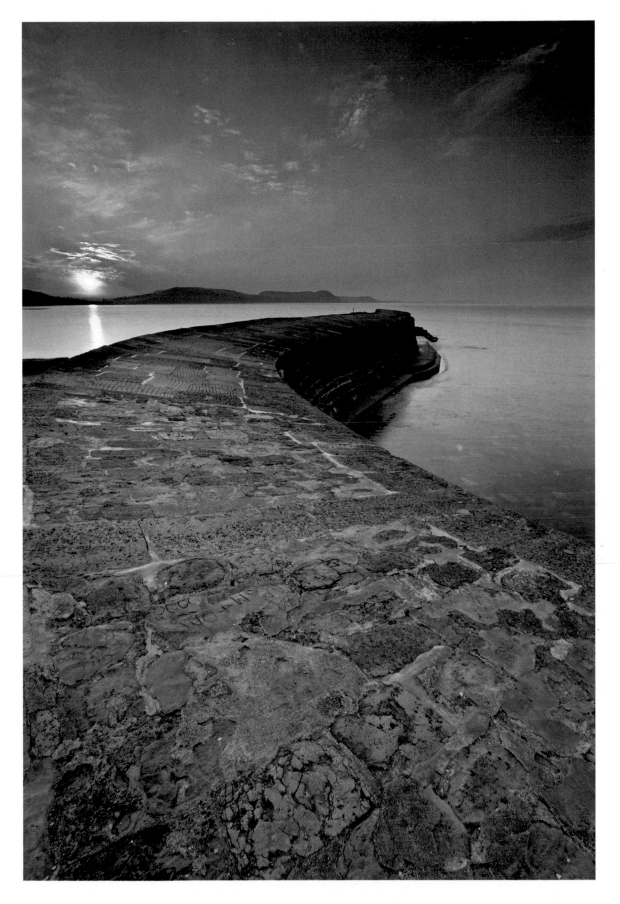

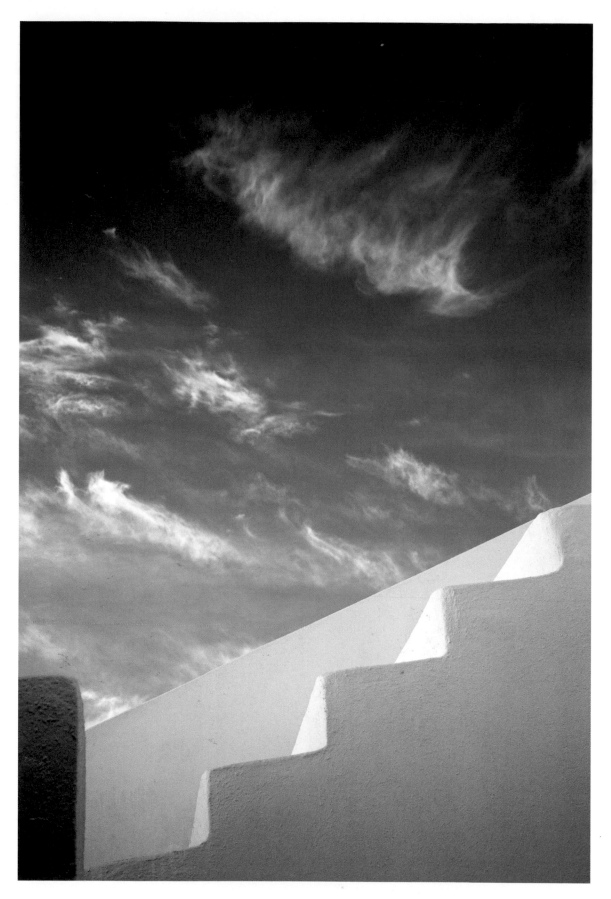

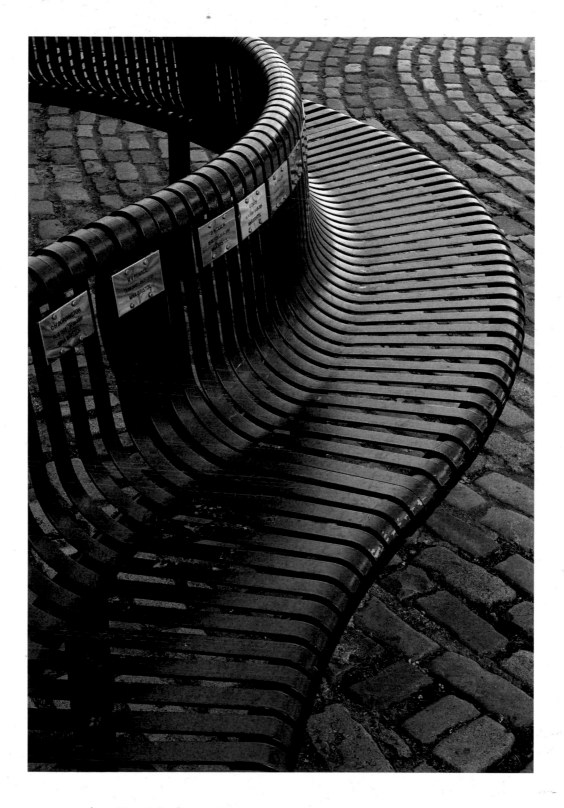

Check before you shoot
Analyse the component parts of the picture and ask yourself if the composition is balanced and the light suitably controlled.

Imagine the picture

Before you press the shutter, close your eyes and imagine how you want the picture to turn out. Is this reflected in your camerawork?

p80 **Chapel near Oia**
Santorini, Cyclades Islands, Greece

Clive Minnitt

p81 **Welsh Back**
Bristol, England

Clive Minnitt

p80

p81

Inspiration: The opportunity to play with a combination of geometrical shapes and fantastic clouds was too good to turn down.

The situation: A pre-dawn start at one of the many blue-domed chapels was amply rewarded by the subsequent appearance of some of my favourite clouds – pre-arranged, of course!

Camerawork: Camera: Canon EOS 5D
Lens: Canon 24-105mm f/4L IS USM at 50mm
Exposure: 0.3 second at f11
Filtration: None
Other: Plus 1/3 exposure compensation, ISO 50

My attempt at being creative whilst working under pressure was one of the highlights of my time on the island. The clouds were present in this form for a matter of seconds, before they changed and no longer bore any relevance to the shapes below. The shutter was pressed at precisely the right moment. **CM**

The light on the left-facing sides of the steps is the key, as is the fact that Clive selected his viewpoint carefully to ensure a good distribution of clouds throughout the sky area. The sky is surprisingly dark at the top of the image given that no filtration was used. This was probably due to the time of day. Once again, by simplifying the colour palette he has created a strong, graphic image. **PM**

Inspiration: I hope that whoever designed the bench did so with the cobbles in mind. Together, they provide a visual treat.

The situation: There are several similarly shaped benches positioned by the edge of the Floating Harbour. I've walked past them on many occasions and always stop to look. It's odd that whenever I'm camera-less I see more pictures than when I'm armed. On this occasion, I meant business.

Camerawork: Camera: Panasonic Lumix DMC-LX3
Lens: Leica DC Vario-Summicron, 3:2 format
Exposure: 1/200 second at f2
Filtration: None
Other: Minus 0.3 exposure compensation, ISO 200

There's much to observe in the picture but, in essence, it is a very simple shot. The most time-consuming part was to clone out all the cigarette butts from between the cobbles. Still, pre-digital I would probably have moved them by hand – YUK! The lovely blue tones emanate from photographing under a blue sky, in the shade. **CM**

I really love this image and also the way that it seems linked to the Santorini image on the facing page (nice work Eddie!). It is amazing how such simple subjects can deliver such powerful images – as Clive mentions there is a lot to look at and the eye roams contentedly around the frame. **PM**

On location:
The Coigach Peninsular

The Coigach Peninsular, north of Ullapool in Scotland, hosted our band of merry photographers – Joe Cornish, David Ward, Phil and I, were joined by Eddie Ephraums and Richard Childs. A plan was hatched: Joe, Richard and I elected to take the high road next morning, whilst the others went to the off-licence to buy dinner.

At the summit of Sgurr An Fidhleir, there was a light dusting of snow. The appearance of a 'brocken spectre' (the hugely magnified shadow of an observer that is sometimes cast on the surfaces of clouds opposite the sun) and a magnificent three hundred and sixty degree view were almost enough to make me forget I was there to take photographs. Mists swirled around the mountaintops and a low sun created shadows of peaks on the sides of other peaks.

The three of us then went into photography mode and hardly a word was spoken until we broke for lunch, nibbling away at Joe's finest veggie mish-mash. The post-banquet session was equally intense. One could almost hear the deathly silence as we pretended not to be competing with one another. Each of us had a different approach, although we all felt the inclusion of foreground interest was vital with such a huge vista facing us. It had to have relevance to the rest of the composition and not be included for its own sake. Joe has a well-defined style, and his image fitted perfectly within it. His exceptional use of foreground elements and the way he lights them are two of the qualities that make his work stand above that of others. His scouting technique has to be seen to be believed. Mountain goats cover less ground!

Richard did well to concentrate as I constantly enthused; his more relaxed style perfectly suited his exquisite image, which was taken from a different angle to mine. My approach was more avant-garde, reacting to what I found to be of interest. On this occasion I found a very strong leading line that drew the eye to the distant, beautifully lit mountains.

Before we knew it, darkness was descending and we made our way down guided by head torches, to be welcomed by Phil, Eddie and David with whisky and cake. **CM**

What type of photographer are you?
Leaving questions of style, genre and approach to one side, how would you describe your photography (in non-photographic terms)? This is tricky, but very revealing and can help you to refine what your photography is really about. For example, wines and foods are often discussed using non-culinary terminology that can describe a wider range of sensory responses.

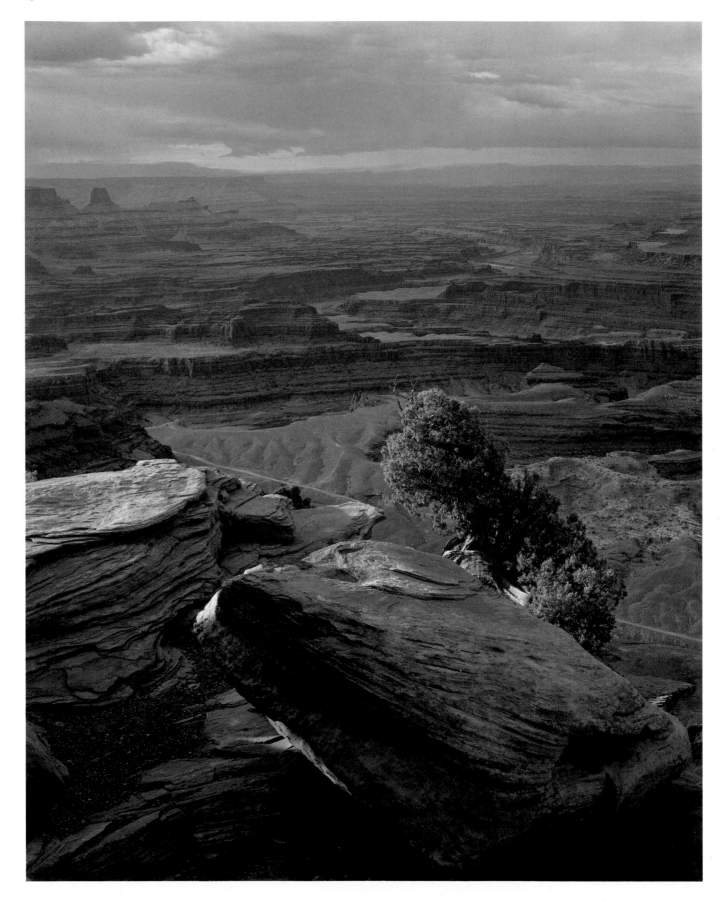

Imagination

When trying to find a picture, there are a number of factors that need to come into play. We have all read the manuals, practised our technique and reached the place where the camera almost becomes part of our anatomy, an extension of the mind, part of a seamless process. It is crucial that the physical act of making an image must not, in any way, be a barrier to our creativity. Working the camera, selecting an exposure, choosing the correct filtration should all come naturally if we are to make the most of our creative potential.

As well as learning the technical side we have studied the work of the masters, absorbed the thousands of fantastic images we have seen, heeded all the advice and invested all the time and effort we can muster. We have also made lots of our own images, some excellent, some disappointing, each one of which has informed us on some level.

Every time we set up the camera and make an exposure we are adding to our own private knowledge bank. It is vital that we make photographs on a regular basis as this continuous feedback gives us something we can build upon. Photography isn't like riding a bike. You cannot expect to succeed if you only make images once every six months when you go on holiday. Inevitably this will mean wasting a lot of time and effort getting back to a level you were at previously. Even when you make images on a regular basis you will experience days when nothing seems to work, when you feel that you have lost your ability to see. This is normal so don't panic.

As you progress on your photographic journey all of this effort, all of the study, the deep thought and the practice will give you the freedom to imagine what is possible. When arriving at a new location or when confronted by a new subject, you will subconsciously call on all of your previous experiences. These will allow you to picture in your mind's eye the best possible image and you will possess the tools and techniques to reach out and grab it. **PM**

The art of anticipation

If you are able to anticipate the light and the movement of clouds, people, animals, vehicles, boats, winds and tides you can hone your image making down to a fine art. Good timing plays an important part. When something occurs exactly as you envisaged and the shutter is pressed at precisely the right moment, you can truly say you made the picture.

Which season?

Photograph the same subject at different times of the year and note how the angle and nature of the light changes.

p84 **Dead Horse Point**
Utah, USA

Phil Malpas

p87 **The Wave**
Paria Canyon and Vermillion Cliffs, Utah, USA

Phil Malpas

p84

p87

Inspiration: This image was made during a photographic tour to Arches and Canyonlands with David Ward and Joe Cornish. I found the endless wilderness inspiring, the fact that as far as the eye could see there was little hint of human influence.

The situation: This was our second visit to this location; the previous day had been dull and overcast. The early morning light on this occasion was a great help to my composition. It was vital to get the correct combination of ND grads to achieve a successful exposure.

Camerawork: Camera: Ebony SV45TE
Lens: Schneider APO Symmar 150mm f/5.6
Exposure: 6 seconds at f32
Filtration: 0.3 ND soft graduated, 0.9 ND soft graduated, staggered
Other: Fujichrome Velvia Quickload, ISO 50

The only blot on this vista for me is the road that runs across the image hundreds of feet below my position. A key element is the small patch of direct sunlight on the base of the foreground boulder which helps to break up the shadows. There is a lot to look at in this image and I find my eye roaming around the far distance with always something new to see. **PM**

The light at the base of the rock might easily have gone unnoticed but Phil has used it to great effect. I can see how the road must have been a dilemma – adopting a slightly different viewpoint might have hidden it but with the camera at a lower angle it would have radically altered the placement of the rock and shrub within the frame. Another option would have been to exclude the sky, giving more weight to the foreground. **CM**

Inspiration: I visited this area with Clive, Joe Cornish and David Ward in 2000. It was a fantastic adventure, particularly knowing that you were very much on your own in this huge area of wilderness. We had seen a few images prior to our visit, mainly by Michael Fatali and Jack Dykinga, and these had inspired us to see the remarkable formations for ourselves.

The situation: To visit the Paria Canyon and Vermillion Cliffs Wilderness area, you need to get a permit. The area is extremely fragile and visitor numbers are limited to a handful each day. Camping isn't allowed so you will be faced with a fairly long journey each day. It is also advisable to hire a 4-wheel drive vehicle as part of the journey involves going off-road.

Camerawork: Camera: Ebony SV45TE
Lens: Schneider APO Symmar 150mm f/5.6
Exposure: 1/15 second at f32
Filtration: None
Other: Fujichrome Velvia Quickload, ISO 50

I made two images of 'The Wave' at the time, one with and one without sky. This one is my favourite as leaving the sky out has removed a sense of scale, making the image more ambiguous. **PM**

The incredible geological contours in the Wilderness challenge the photographer to use imagination and graphic design skills, as Phil has succeeded in doing. Harsh overhead light has been avoided by waiting until the sun was obscured by cloud. **CM**

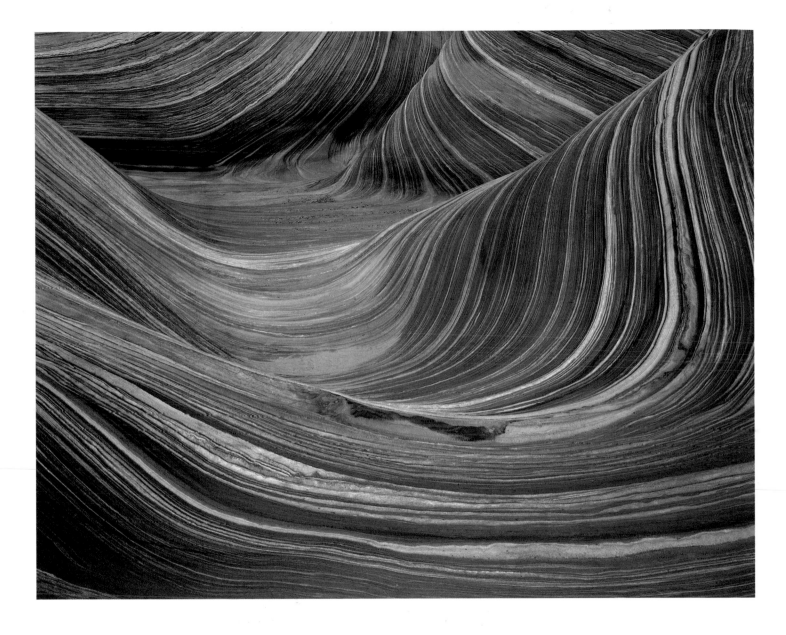

Clouds or clear skies?

When does a cloudless sky work and when not? Clouds might be included to echo the shapes and forms in the composition, but for other scenes their presence can detract from the structure of the picture.

Interest and passion

We inevitably form a connection with subjects that particularly interest us or about which we are knowledgeable or passionate. When we photograph these subjects it not only gives us great pleasure but we are also likely to produce some of our best work.

Know your location

Becoming acquainted with a location will help you to observe and understand variations of weather and light and determine what works and what doesn't.

p88 St. Andrew's Park
Bristol, England
Clive Minnitt

p89 St. Andrew's Park
Bristol, England
Clive Minnitt

p88

p89

Inspiration: A windy day meant the park was almost deserted. The contrast of the more delicate, foreground tree and the sombre, majestic beastie behind it intrigued me. They were worthy of a picture.

The situation: I was precariously perched on a perimeter wall, as I needed to gain height to avoid including parts of trees that would have spoilt the image.

Camerawork: Camera: Canon EOS 5D
Lens: Canon 100-400mm f/4.5-5.6L IS USM at 220mm
Exposure: 30 seconds at f29
Filtration: 0.6 ND, polariser
Other: ISO 200

I set out to avoid any daylight showing through the trees. It was a challenge to achieve this whilst retaining the composition I had in mind. **CM**

Many of us put a lot of effort into avoiding movement in our pictures. This image shows just how wonderful movement can be – the unique ability of photography to show us a period of time in a single moment. Clive was correct to avoid any bright highlights in the background trees which would have instantly distracted the viewer's attention from the main subject. **PM**

Inspiration: One way I earn income is to produce and market hand-made greetings cards. Local scenes sell particularly well. I am often seen in this park, dodging the dogs and keeping my tripod legs under guard just in case. This image will be made into a card.

The situation: For an inner city park this one takes some beating – and it's only 400 yards from my home. The four seasons provide a never-ending supply of picture-making possibilities. A little patience was necessary as I had to wait for people to amble through the scene. I'm not the only one who loves the park, after all!

Camerawork: Camera: Canon EOS 5D
Lens: Canon 100-400mm f/4.5-5.6L IS USM at 135mm
Exposure: 20 seconds at f25
Filtration: None
Other: ISO 50

Spaces between the trees were vital and I almost succeeded in keeping them apart – there are just two that overlap. What I like most about the picture is that having fewer leaves on the branches seems to have given a better result than when they were fully laden only a few days before – sometime a good wind really helps. **CM**

I think Clive's comment about overlapping trees is being a little too self critical. I really love the way the lower parts of the trunks are picking up blue colour from the sky and the contrast this creates with the yellow leaves. The slight movement caused by the breeze gives the image a wonderfully impressionistic feel. **PM**

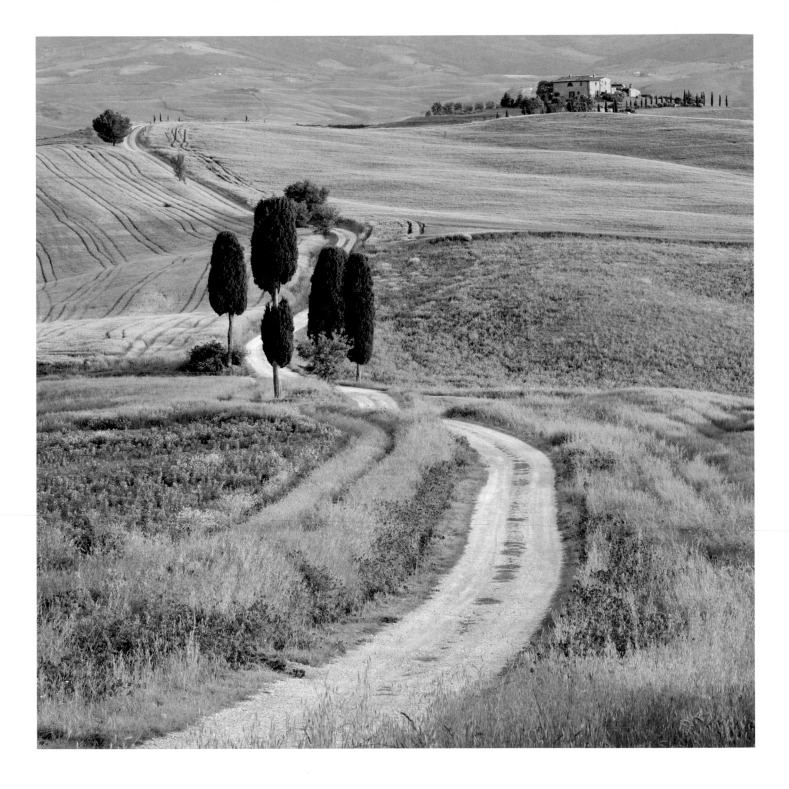

Break the rules
By all means learn the rules of composition but don't be afraid to break them.

Working in low light

Don't restrict your sunrise and sunset photography to when the sun is above the horizon. During twilight and after sunset, light levels should be ample for moody images.

p91 **South of Pienza**
Tuscany, Italy

Phil Malpas

p93 **Little Langdale**
The Lake District, England

Phil Malpas

p91

p93

Inspiration: This location was made famous after it was used in the movie *Gladiator*. Russell Crowe stood in the crops close to this road as he dreamed of his young family.

The situation: The owners of the house on the hill were extremely proud of their brief association with Hollywood and showed us lots of pictures of the way things were when the film crews were on site.

Camerawork: Camera: Canon EOS 1DS MkIII
Lens: Canon EF 24-105mm f/4L IS USM at 105mm
Exposure: 0.6 seconds at f16
Filtration: 0.6 ND hard graduated, polariser
Other: ISO 50

I composed this image as a square 'in camera', a facility I find extremely useful on my DSLR. I wanted the road to lead the viewer through the image to the house on the hill via the cypress sentinels that provide balance in the centre left of the frame. **PM**

Quick lateral thinking and good imagination! This scene definitely suits square format and although it is quite possible to shoot in 35mm format and crop it, it doesn't have the same feel-good factor. In an ideal world there would have been a gap between each tree but it wasn't to be. The splash of red clover lifts the foreground perfectly. This lovely composition simply says 'Tuscany'. **CM**

Inspiration: This is a location I have visited many times, but usually my interest has been directed in the opposite direction across Blea Tarn towards the Langdale Pikes. On this occasion the fantastic dawn light attracted my attention and it was simply a case of finding an interesting foreground.

The situation: The image was taken at about 08:30 on New Year's Eve, just ten days after the shortest day, a time of year when sunrise is very civilized. I had left my hotel in plenty of time, however, and was glad I had done so, as the road leading to Blea Tarn was very icy.

Camerawork: Camera: Ebony SV45TE
Lens: Schneider Super-Angulon 90mm f/8
Exposure: 15 seconds at f32
Filtration: 0.45 ND soft graduated, 0.9 ND soft graduated, staggered
Other: Fujichrome Velvia Quickload, ISO 50

The view down into Little Langdale was my main subject, and I had been attracted to the small orange-flowered heather in the central foreground. I would have liked to have shot slightly wider, which would have meant moving the camera back slightly. This would have given some space around the foreground rocks, but unfortunately immediately behind me was a thirty-foot drop! **PM**

I offered to look after his camera and tripod should he wish to see what the view was like from further back! The clarity of the foreground detail is what sets a large-format camera apart from other formats. I agree with Phil, the rock on the right either needs space around it or it could be cropped further – which might help to include more of the angular rock to its left. **CM**

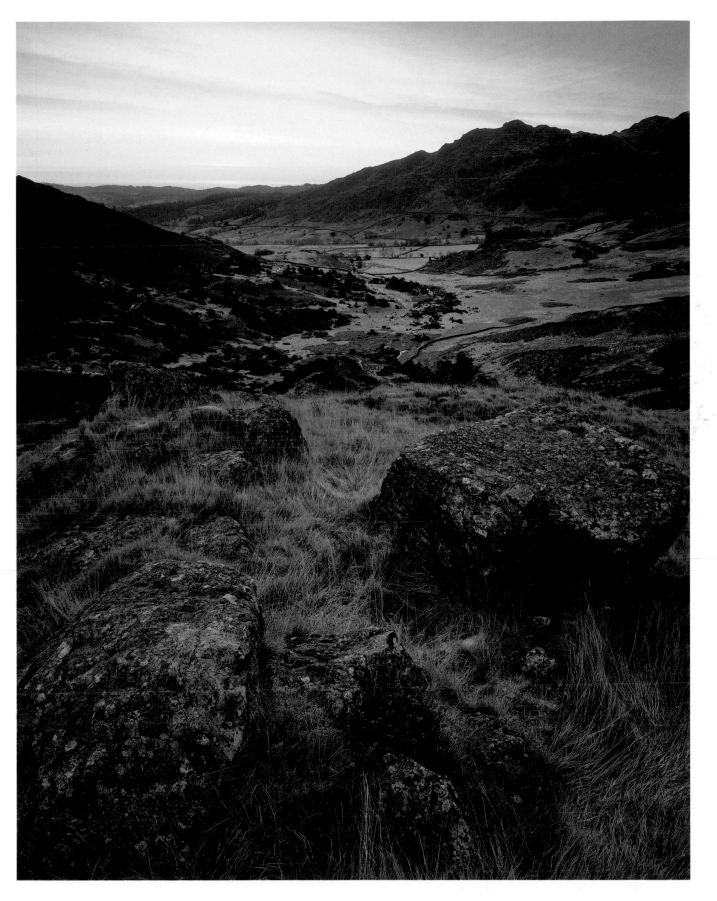

Developing your vision

Which focal length?

Having a good understanding of your camera equipment is essential. Experiment by using a variety of focal length lenses (single focal length lenses and/or zoom) to photograph the same scene. This will give you an appreciation of how much of the subject matter each lens will allow you to incorporate within your compositions.

We all have our own unique way of seeing the world. Our photographic vision is simply the way we translate that personal vision into visual images, something that evolves and changes as we develop on our photographic journey. Once we accept that our photographic vision isn't fixed, isn't something we are born with and will take with us to the grave, it is also possible to see how we can shape it. We can learn to develop it through conscious effort and training as well as subconsciously through the influences we take on board.

If our photographic vision is simply an interpretation of the way we see the world, then in order to improve that vision we have to change the way we see. This isn't easy. It requires time, patience and effort, but there are certain tools and techniques that can show us the way forward.

Set yourself a challenge to photograph something you've never attempted before. If you usually photograph when the weather is fine, go out in the wind and rain and see what you can come up with. If you normally shoot big views, spend a week shooting nothing but close-ups. Try making an image where the camera is close to the ground or perhaps try photographing when you are lying on the ground looking up. Devise a project which involves shooting images that contain only one colour. Use a really wide lens to take a portrait or a really long one to capture a landscape. Whatever rules you thought existed in photography, go out and break them. Something exciting might just happen! It may be that you don't like many of the results you obtain, but at least you will learn from the process.

It is highly likely that almost every location we consider to be photogenic has been photographed many times before we get there. We are usually aware of iconic images we have seen of a particular place. If you are planning to visit such places, do not try to copy these images. Use your own personal vision to improve on them, try something new and create the next icon. **PM**

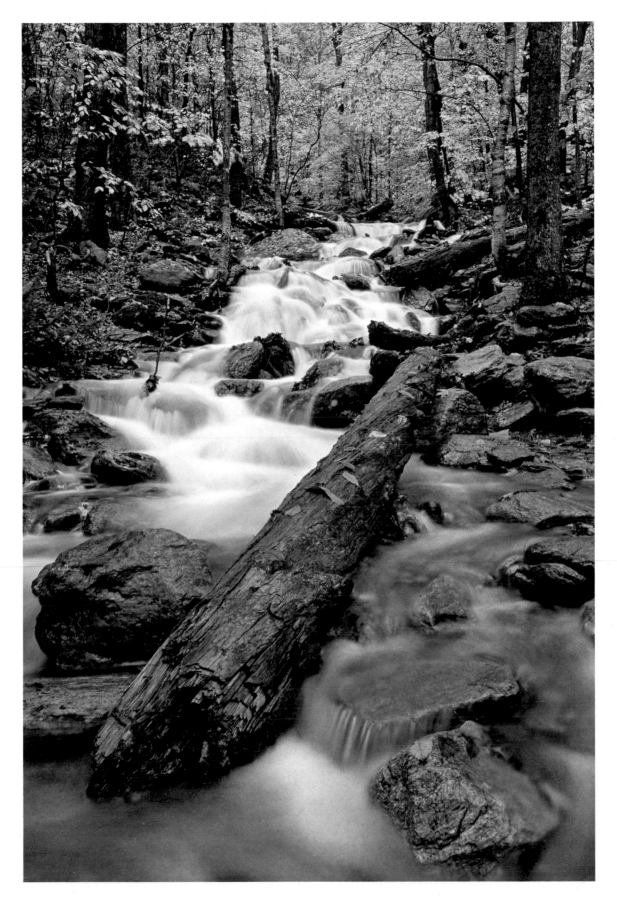

Check the fine details

It is the minutiae that can either make or ruin a photograph. Check the composition carefully in the viewfinder.

p95 Smuggler's Notch
Near Stowe, Vermont, USA

Clive Minnitt

p97 Lower Antelope Canyon
Arizona, USA

Phil Malpas

p95

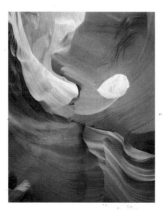

p97

Inspiration: 'Leaf peepers' galore visit Vermont in the fall to celebrate the beautiful kaleidoscope of autumnal colour. Fortunately, Phil and I have several years experience of leading tours to the region and are able to explore some of the lesser-known areas, steering clear of the crowds. We never fail to be inspired by the almost continuous woodland that stretches from Boston to the northern parts of Vermont and beyond.

The situation: As usual when we visit this woodland, it was a wet day. A damp, overcast day is perfect as it reduces the contrast and enhances the colour of the leaves.

Camerawork: Camera: Canon EOS 1
Lens: Canon 100-300m L
Exposure: Settings not recorded
Filtration: Polariser
Other: Fuji Velvia transparency film, ISO 50

Daylight peeping through the trees can be a distraction but by cropping tightly I was able to exclude it. There's a small branch in the water (halfway up on the left) that I tried to reach and move but I would have had a good soaking had I succeeded. Some would say it isn't an issue (the branch not the soaking!) but I say once you know it's there you can't take your eyes off it. See what I mean? **CM**

I remember this day very clearly and Clive's comment that it was wet shows his talent for understatement. It was torrential and we were all taking it in turns to hold umbrellas for each other. What these conditions do provide is fantastically rich colour, which he has enhanced through his use of a polariser to cut down glare. Maybe I'm strange, but I find it reasonably easy to ignore the offending stick. **PM**

Inspiration: This image was made on my second visit to Antelope some two years after my first. I was determined to learn from my previous attempts and to try to capture more of the wonderful light. Many of the images I had seen previously were fairly dull, brown affairs. We spent over five hours in the canyon, which seemed like five minutes. The photographic possibilities were endless.

The situation: This is a famous and often photographed section of the Lower Canyon. This visit was later in the year than my previous one and I was amazed at how quickly the light changed as the sun tracked across the sky above. Great care was needed to avoid 'hot spots' of direct light that could appear both between and during separate exposures.

Camerawork: Camera: Ebony SV45TE
Lens: Schneider Super-Angulon 90mm f/8
Exposure: 8 seconds at f22.67
Filtration: None
Other: Fujichrome Velvia Quickload, ISO 50

I am still amazed at how important the small section of lit rock in the bottom left corner of the frame is to the success of this composition (try covering it up to see what I mean). I don't recall being fully aware of its significance at the time, but I like to think my subconscious kicked in and it was included simply because it was 'right'. **PM**

Visits to this slot canyon taught Phil and I much about photographing in reflected light. A growing awareness of what kind of light is most suited to the subject opens up many more exciting possibilities. **CM**

A quest for excellence
Don't accept second best. Always strive to produce images of the highest quality.

Suitable light

Any lighting conditions, from dull to bright, are workable. It is a matter of choosing your subject appropriately. It doesn't have to be dramatic but suitable.

p98 **Festival Pier**
South Bank, London
Clive Minnitt

p99 **Old West Church**
Vermont, USA
Clive Minnitt

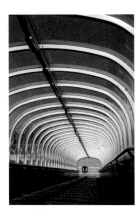

p98

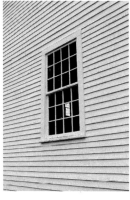

p99

Inspiration: Phil tells me, that Henri Matisse told him, that a thimble of red is more powerful than a bucketful – and how right they both are! This is my humble attempt to illustrate the point.
The situation: I spent a very pleasant couple of hours meandering along the South Bank where there are many subjects to photograph. I had walked past this pier a couple of times and hadn't taken much notice. On the next lap, I did a double-take and was bowled over by the vivid colours and the way that all lines pointed to the red lifebelt.
Camerawork: Camera: Canon EOS 5D
Lens: Canon 24-105mm f/4L IS
USM at 45mm
Exposure:, 1/15 second at f20
Filtration: 0.3 ND hard graduated, polariser
Other: Plus 1/3 exposure compensation, ISO 50

A very powerful, graphic image. **CM**

Henri Matisse actually said 'A thimble full of red is redder than a bucketful', and I know I'm getting on a bit Clive but I haven't quite been around long enough for him to 'tell' me. You are right though when you say that this image clearly illustrates his point. **PM**

Inspiration: When you have a bee in your bonnet about something you can't relax until you have achieved your goal.
The situation: I was convinced I would find a shot of a window through a single pane of another window, if that makes sense. It took me 45 minutes to find it. Of the fourteen windows I thoroughly investigated, there really was only one position where the picture worked. The following year we re-visited the church and I had a lucky escape. As I posed the same challenge to the group, camera sitting safely on my tripod, the dog from next door came to play. It suddenly ran towards my camera and tripod, spun round as it got to within a couple of feet, and knocked a leg of the tripod into the air with its tail. The tripod leg remained like that for what seemed an eternity before returning to its original position with no harm done. All in the line of a day's work.
Camerawork: Camera: Canon EOS 1
Lens: Canon 28-70mm L USM
Exposure: Settings not recorded
Filtration: None
Other: Fuji Velvia Transparency Film, ISO 50

Part of the fun of making an image is having to work hard to make it succeed. I'm delighted with this result, mainly because of the fact that I had to persevere. Many photographers prefer not to include angles that are not truly vertical or horizontal – I believe that exaggerated angles can have quite an impact. **CM**

This was a case of imagining the possible then striving to achieve it. Not many photographers would have had the persistence, tenacity and belief to realise this composition. **PM**

On location:
In Venice with Charlie Waite

Books and magazines can teach us so much but there is nothing like having a good mentor. When I was at school, my favourite lesson, and the one that I excelled at, was sport. This undoubtedly had something to do with my PE teacher, who was by far the most enthusiastic, encouraging and inspiring of all my teachers. He helped me understand the need to train hard (and intelligently) in order to succeed. He also made the subject fun.

Having a mentor has been just as important to my development as a photographer. I first started to appreciate the power of photography in the winter of 1982, when I had two months off work following an arm operation. To fill the time, I planned to walk the length of the Cornish Coastal footpath, and searched bookshops and libraries for relevant reading material to take with me.

One particular book caught my attention. It was *The National Trust Book of Long Walks*, written by Adam Nicholson in conjunction with a photographer called Charlie Waite. I was truly inspired by the photography and, for the first time, something within me clicked, in an artistic sense, if you will excuse the pun. Did they really walk all those miles?

The book totally changed my views on photography, helping me to appreciate what magical, emotive images could be created with a camera, compared with the 'snapshots' that I had previously produced.

The name Waite never left me. When I later read in the photographic press that the same Charlie Waite was leading workshops, I jumped at the chance to join him, and a few others in need of inspiration, in Venice. The standard of his work had progressed immeasurably – mine hadn't!

For the first time since my schooldays I met someone who had the ability to inspire me in many ways and who could help me to help myself. I studied Charlie's work closely and tried to put into practice the principles he followed in his photography. He helped me to 'see' Venice differently. There were infinitely more picture possibilities than I had previously imagined.

Many years later, I still benefit greatly from his friendly guidance. **CM**

Work with the conditions

No matter how hard you try to make a picture idea work, there will be times when it is right to abandon it. Capturing a stunning image is not always possible when you are at the mercy of the weather and your pre-visualised picture doesn't materialise. In these situations, it's best to turn the conditions to your advantage and work with them to produce something unexpected.

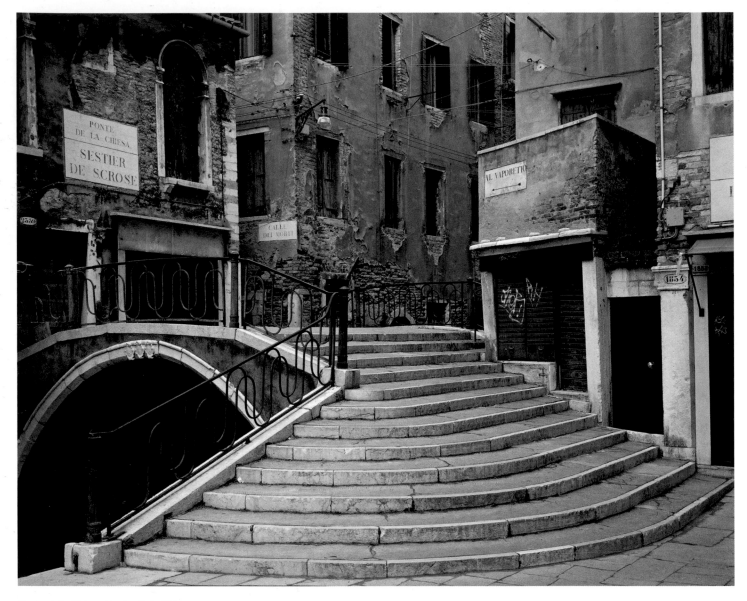

Ponte de la Chiesa, Venice, Italy. **PM**

Study other photographers' work
See how others have approached a subject by looking at postcards, greetings cards, calendars and travel books. Look at the bad as well as the good.

How to simplify your pictures

Creating a balance | On location: Slapton Sands | Understanding colour | Choosing the right moment | On location: The Second Severn Crossing

You've found a rusty old bicycle you'd like to photograph. How are you going to produce a picture that does it justice? Imagine how you would like it to look, framed and displayed in a gallery, admired by others. The bicycle has so much character, but the big question is where to place it in the frame?

To answer this you need to know more about what's in the background. What is the bike leaning on? Perhaps part of the frame and half a wheel would make a better picture than the whole? The rusty colour clashes with the bright red barn door. Overhead sun is reflecting off the chrome giving unwanted highlights – is it the right time of day? Perhaps it is better to come back another time but that begs another question – will the bicycle still be there? If only photography were less complicated!

Balance in compositions and the careful use of light and colour are important considerations. Seeing one of your images hanging on a wall or in a gallery will say something about the quality of your photography. It will be evidence that you have grasped the concepts we will discuss in this chapter, and that your artistic talents have progressed to such a level that you can't wait to share your work with others. Beware, it's addictive! **CM**

Creating a balance

Composition can be a challenging skill to master, and almost every photographer will adopt a different approach. Understanding and using some or all of the following pointers will help you to simplify and improve your compositions.

A common mistake is to include too many elements. That isn't to say chaotic scenes should be avoided altogether but there must be some sense of order or meaning created rather than a pictorial mish-mash.

Images are more visually pleasing when the composition is balanced. Formal balance or symmetrical composition is where an image is split, either in portrait or landscape format, or both, each half being a perfect mirror image of the other. A good example would be a tree and its reflection in a lake.

Informal or asymmetrical balance is subjective and more frequently used. Although it allows much more latitude in your compositions it is important to work carefully with the shape, colour and size of each element as well as their relative positioning. Random placement rarely works.

Consider using the 'rule of thirds'. Divide the picture into three equal sections vertically and three horizontally. The four intersecting points are excellent positions in which to place the focal point of the image. Compositions with proportions of 80 percent land and 20 percent sky (or vice versa) are also pleasing to the eye.

Attention to detail is paramount. Look out for any imperfections which might detract from the composition. Remember that white and red are the colours that stand out most. Before pressing the shutter, look around the edges of the picture through the viewfinder and check for unwanted items.

Use differential focusing techniques to emphasise a selected area. Opening the aperture wider will reduce the depth of field.

A 'less is more' approach usually works. Including part of a subject is often better than attempting to photograph the whole. If the sky doesn't add anything, exclude it. It is important to consider every part of the composition, not just the main subject.

There are no hard and fast rules about how to create a balanced picture. It is largely a matter of personal taste, although viewing the end result back to front or upside-down on the computer screen (by flipping or rotating) makes it easier to spot imperfections. Time spent fine-tuning the image will be extremely beneficial. **CM**

Look for relationships

Avoid compositions in which the elements compete for attention within the frame. Look for relationships between elements and use leading lines to take the eye towards the focal point. Compositions may be 'open' (where the picture leads from left to right) or 'closed' (right to left).

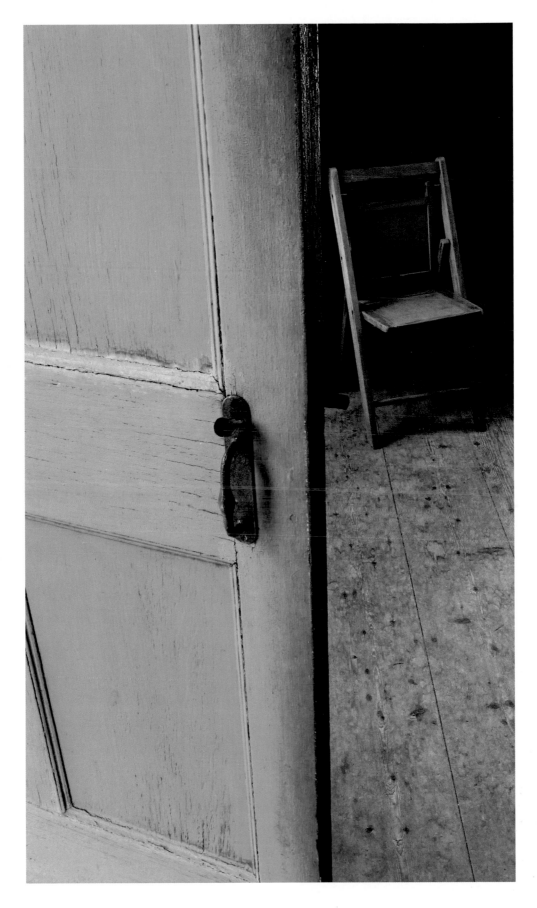

Communicating ideas

What do you want to communicate through your photographs? Try summarising your aims in a word or two and use this to help focus your vision and composition.

p105 **Old West Church**
Near Montpelier, Vermont, USA
Clive Minnitt

p107 **Oia**
Santorini, Cyclades Islands, Greece
Clive Minnitt

p105

p107

Inspiration: Generally, churches contain a plethora of interesting subject matter. Old West Church is special for the simple reason that there's hardly anything inside it, but lots to photograph.
The situation: The entrance lobby contains a chair, an old organ, a small table, and two wooden staircases leading to the upstairs gallery. The half-open front door caught my eye. The image is about light and patient fine-tuning of the composition.
Camerawork: Camera: Panasonic Lumix DMC-LX3,
Lens: Leica DC Vario-Summicron, 16:9 format
Exposure:, 1/10 second at f8
Filtration: None
Other: Minus 0.3 exposure compensation, ISO 80

The gorgeous light falling on the leading edge of the door changes very subtly from top to bottom. The relationship of various chair parts to this edge, and to the door latch, were carefully thought out, taking some time to achieve. **CM**

Clive and I have visited Old West Church on many occasions, so it is interesting that he only discovered this view on our most recent trip. For me, this shows how at different times we can be receptive to different things and that it is always worth revisiting a familiar location. **PM**

Inspiration: Simplicity; hardly any subject matter but plenty to think about in terms of how to make the most of what there is. I could indulge myself for hours.
The situation: Even though direct sunlight was absent from this courtyard it was still very bright. Light reflected from nearby buildings created a lovely warm atmosphere.
Camerawork: Camera: Canon EOS 5D
Lens: Canon 24-105mm f/4L IS USM at 105mm
Exposure: 1/160 second at f5.0
Filtration: None
Other: ISO 50

One of my pet 'likes' is leaving space between the elements in a picture – but only when it improves the composition. With this image I think I fell between two stools – excuse the pun! I should have either created a gap between the table and chair or had them overlap more. **CM**

The table does overlap the chair, but in some ways I think this cements their relationship and makes the picture more about a single subject rather than two separate items in the frame. The colours are absolutely gorgeous and Clive's ability to recognise the potential in such a simple subject is to be applauded. **PM**

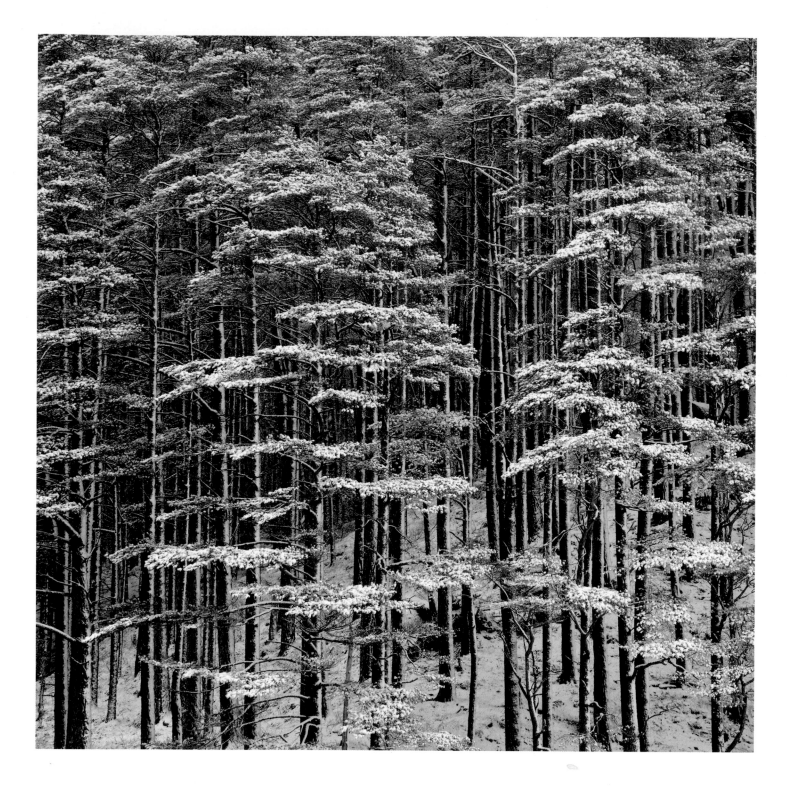

Know your subject
The more absorbed you become in a subject, the more you will be tuned in and able to discover things that interest you.

Plan your photography
An in-depth knowledge will lead to a greater understanding of the subject,
enabling you to plan your photography better.

Angle of light

Think about the direction the subject is facing. What would be the best time of day or year to photograph it, for example if you want low light coming from a particular direction? Is now the right time?

p108 **Snow on trees**
Glen Orchy, Scotland
Phil Malpas

p109 **Snow and grasses**
Rannoch Moor, Scotland
Phil Malpas

p108

p109

Inspiration: When David Ward insisted we stop at this location during a photographic tour to Glencoe in 2009, I have to confess to thoughts of returning to a warm cup of tea. The temptation was soon forgotten, however, once I started to compose an image of this fantastic stand of trees.

The situation: Towards the end of a day of almost continuous snow, we stopped at this stand of trees near the upper end of Glen Orchy. The trees were on a small hill and created a wonderful domed shape, but the absence of any detail in the sky forced me to crop to this composition.

Camerawork: Camera: Canon EOS 1DS MkIII
Lens: Canon EF 24-105mm f/4L IS USM at 105mm
Exposure: 0.6 seconds at f16
Filtration: None
Other: ISO 50

In places it was possible to see the sky through the trees and I worked hard to choose a section that avoided these bright patches, which would draw the viewer's eye. I am pleased with the slenderness of the trunks and the way that they appear incredibly tall and delicate. **PM**

The snow has transformed this dull forest into a magical scene. Snow sticking to the sides of the trunks has added another positive dimension to this image. It's important to clearly see the base of one of the trees as it gives a sense of scale. **CM**

Inspiration: I was inspired by a fantastic image by David Ward called 'Blue Snow', one of my favourites. It contains just three small groups of grass lit by warm sunlight against a perfect snowy backdrop that picks up the colour of the blue sky above.

The situation: After a freezing dawn on Rannoch Moor during a photographic tour to Glencoe in 2009, some of the clients were keen to retire to the warmth of the bus. Whilst waiting for the rest to return I noticed this small patch of delicate grasses at the edge of the car park.

Camerawork: Camera: Canon EOS 1DS MkIII
Lens: Canon EF 24-105mm f/4L IS USM at 40mm
Exposure: 1/6 second at f11
Filtration: None
Other: ISO 50

This image would only work as a square. This was the shape the small patch of grasses made and any other crop wouldn't have made sense. I worked hard to make sure that as far as possible, there was space all around the edge of the frame. There is slight wind movement in some of the blades, but on such a windy day, it would have been impossible to avoid this. **PM**

Lovely, delicate grasses are such a contrast to the strength of the trees opposite. I think it's a bonus that the grasses are pointing in different directions and the movement in some makes it even more appealing. **CM**

On location:
Slapton Sands

To call three miles of shingle beach 'Slapton Sands' is a bit odd. At one end is the hamlet of Torcross, famed for being used as a training ground in the Second World War by the US Army, when they were preparing for the D-Day invasion. Hundreds of servicemen died when an exercise went tragically wrong. A Sherman tank is on display as a reminder.

I was here for happier reasons. Anne and I were on our first date and it was Valentine's Day. The pub at Slapton, which is in Devon, was beckoning as we neared the end of a scenic, seven mile circular walk. A chilling breeze coming off the sea meant we had to keep moving to stay warm.

Before heading inland I stopped to take one last look at the beach and was stunned into action. The sun was setting over the land but the beauty was in the opposite direction. A fantastic, angled bank of cloud was hovering above the horizon and was a perfect match for the breaking waves; between them, they formed a spectacular natural wedge.

Low light coming from my right skimmed the shingle, highlighting individual ridges that had formed around every footprint, while each hollow gave shadow areas of just the right intensity. It took my breath away.

Anne shielded the sun from my lens as I composed my picture. I had little time left but had to work carefully to make sure I got it right. Getting a perfect balance was crucial; I had to find the right angle for the highlighted shingle ridges to work in opposition to the cloud; what ratio of land to sea and sea to sky should I have? The next few waves were feeble and failed to form the 'wedge' with the clouds that I'd spotted earlier. Damn! Then it happened – the perfect wave. I got it.

At the pub, we opened a bottle of champagne to celebrate the start of our relationship (and the taking of a great photograph!). **CM**

A little luck

It is impossible to rely totally on the weather. There will be times when an element of good luck helps you to create a successful image – you just happen to be there at the right place at the right time! Every photographer experiences it and wants it to occur again.

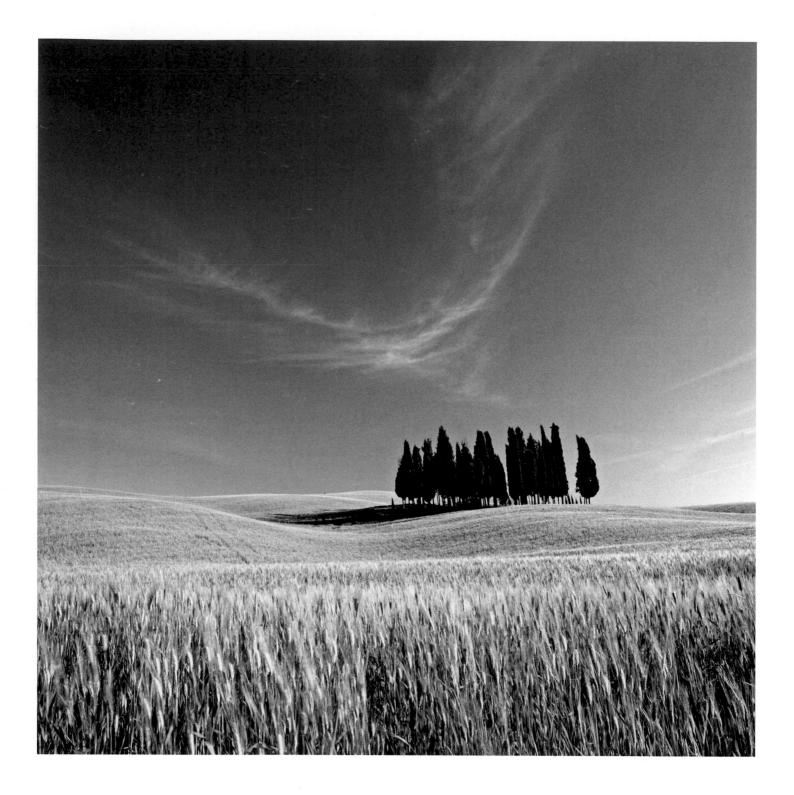

Permission to criticise
When seeking feedback on your images, let people know they can say whatever they want. Simply asking for comments is not the same as granting permission to criticise.

Understanding colour

Understanding what works

There is no magical formula for creating a 'successful' image. In the same way that a musician doesn't have to read music to be able to play an instrument proficiently, a photographer doesn't need a photographic degree in order to create a stunning image. An understanding of a few basic principles will be sufficient. You create the mood, atmosphere and feeling for the viewer to appreciate.

When selecting the elements to include in a photograph, it is important to consider their colour. Colour is a key compositional tool and by carefully selecting the range of hues, you can add mood, emotion, impact and energy to an image.

Colour is also useful for simplifying images. It can be removed completely by converting to monochrome, or you might choose to limit the palette of colours to one particular hue. Another option is to only select colours that work well together. Complementary colours such as blue and yellow serve to maximise the colour contrast in an image regardless of the relative densities of the different elements. Colours that are similar to each other such as warm or cool colours minimise colour contrast and help to add mood and emotion. For example, blue and green are tranquil colours that promote feelings of peace and well being. Orange and yellow are exciting and vibrant and suggest youth and energy. One of the most powerful colours to use in your work is red, especially when it fills only a small area of the frame.

If you intend to sell your photographs, colour selection becomes even more critical. People who buy prints will undoubtedly have a hanging location in mind before parting with their cash. They are more likely to select a photograph that fits well with their existing colour scheme, so it is advisable to have a variety of pictures of limited hues in your portfolio of prints.

In addition to considering the colour of the subject of a photograph, it is also important to take into account the colour of the light that illuminates them. If you use a digital camera you can experiment with the white balance controls either at the taking stage or during RAW conversion. If you shoot film you should familiarise yourself with colour temperature filters.

One last thing to consider is that contrast is the enemy of colour photography. Any object that doesn't fit within the dynamic range of the medium you are using will be rendered as either black or white regardless of its true colour. **PM**

Pictures into words

Invite others to look at your images and ask them what words the pictures communicate. Are they anything like what you had in mind?

p112 'The Clump'
Tuscany, Italy
Phil Malpas

p115 Santorini
Cyclades Islands, Greece
Clive Minnitt

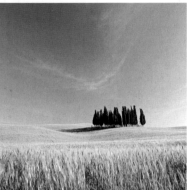

p112

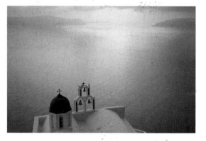

p115

Inspiration: Any photographer who has visited this part of Tuscany will be familiar with this stand of trees. I have seen many images of it, taken in all conditions at all times of year. It is amazing how varied they are.

The situation: Just off the main road from Siena to Rome, this view looking south can be very different at the beginning and the end of the day. This is late afternoon and so the shadow of the trees is clearly visible, whilst at dawn the light would be coming from the left and the shadow would be beyond the ridge line.

Camerawork: Camera: Canon EOS 5D
Lens: Canon EF 17-40mm f/4L USM at 23mm
Exposure: 1/8 second at f16
Filtration: 0.6 ND hard graduated, polariser
Other: ISO 50

My main objective was to maximise the colour contrast between the blue sky and the yellow crop. The elegant cloud formation was crucial to break up the huge blue expanse above the trees. I had to wait a short time for the cloud to move into the optimum position. **PM**

Without the cloud I would have said the trees were positioned too far to the right. However, waiting until the cloud drifted into place meant Phil was able to reposition them and maintain a good balance. When the cloud formed almost in front of our eyes, it created an unbearable yet exciting tension. As fast as they form they can just as quickly disintegrate and the picture is lost. Not this time though. **CM**

Inspiration: On numerous occasions I've had to pinch myself, appreciating how lucky I am to visit such beautiful locations. Santorini is known as a romantic holiday destination and magical settings such as this show just why. To sit, watch and listen was all the inspiration I needed for picture-making. However, beauty is in the eye of the beholder and locations work in different ways for different photographers.

The situation: As dusk approached, a large dark cloud formed, covering the sun. It was perfectly positioned and presented me with many more options.

Camerawork: Camera: Canon EOS 5D
Lens: Canon 24-105mm f/4L IS USM at 47mm
Exposure: 2 seconds at f18
Filtration: 0.6 ND hard graduated
Other: Minus 1/3 exposure compensation, ISO 50

I hope I have conveyed the feeling I had at the time – a sense of peace and tranquility. The chapel was placed in the composition in such a way that it didn't dominate. **CM**

This was one of the first images Clive showed me on his return from Santorini. The soft pastel colours and gentle surface of the water convey a deep sense of peace and tranquility. This is by no means a standard composition and yet it clearly works. There would have been a strong temptation to make the chapel the main point of interest, but he has created a more successful image by refusing to do so. **PM**

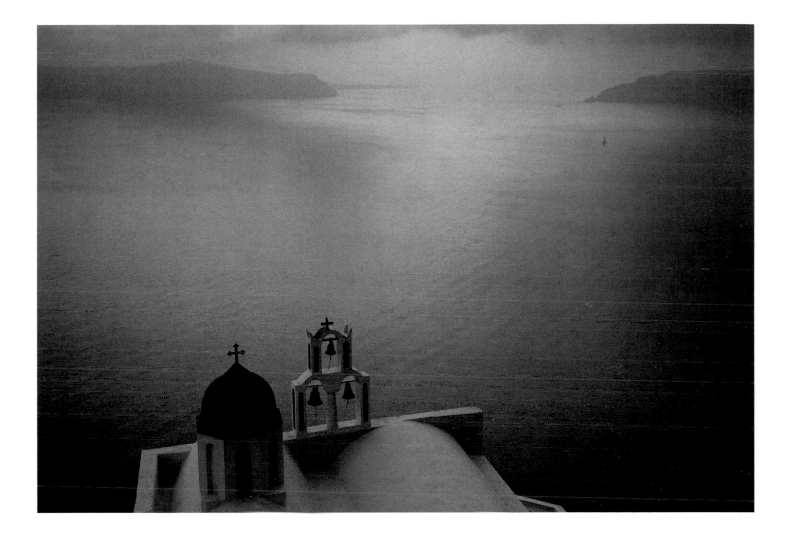

An emotional response

*Think about the emotional response the viewer might have and how
you can create an image which generates that response. Do you
want to invoke a mood of sadness, happiness, anger, exhilaration.
serenity or something else? Do you want to entice the viewer into
visiting the location so they can see what inspired you.*

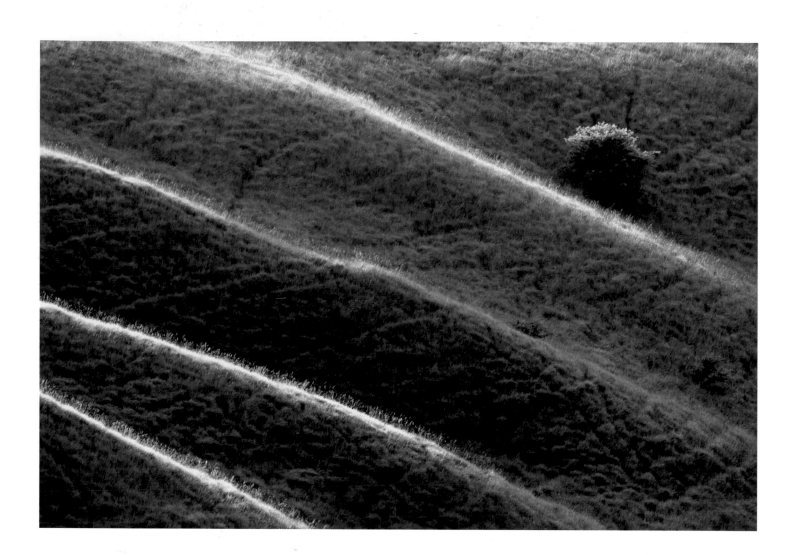

The art of symmetry
Symmetry isn't just found in the shapes and the forms within a composition but also between complementary colours, light and shade, texture and tone. The art of symmetry is being able to balance them all.

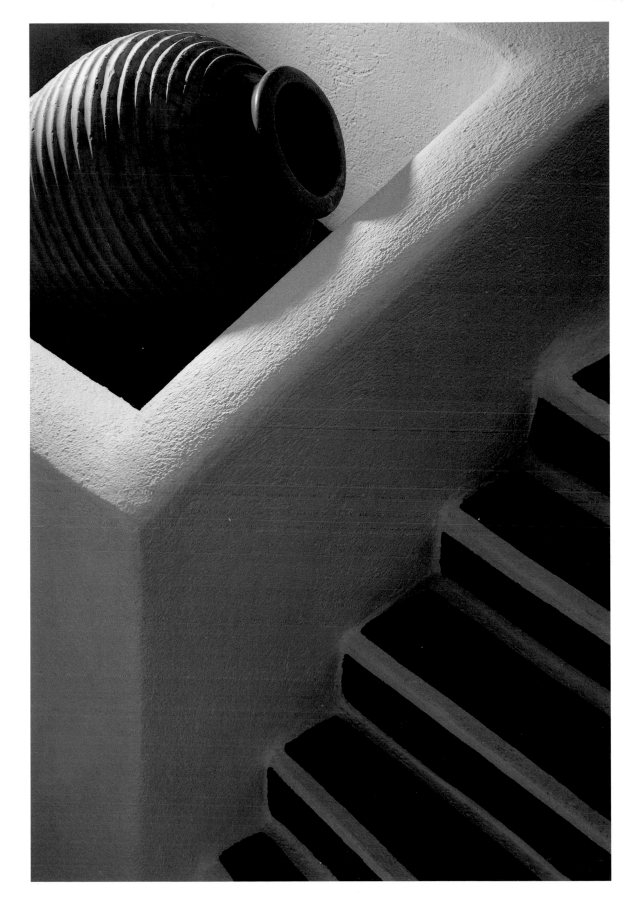

A personal approach

Do you look at a subject purely in terms of the physical relationships within the frame; or the shape and form, light and shade; or are you tuning in to how you feel about it?

p116 **The Manger**
Uffington, England

Phil Malpas

p117 **Firostephani**
Santorini, Cyclades Islands, Greece

Clive Minnitt

p116

p117

Inspiration: The first image I ever saw of The Manger was in Charlie Waite's inspirational book *The Making of Landscape Photographs*. As this location is only a few miles from my home, it has become a favourite haunt.
The situation: The late afternoon sun is just kissing the tops of the ridges, highlighting their wonderful shapes. The small tree adds a focal point and lends a sense of scale to the image.
Camerawork: Camera: Canon EOS 10D
Lens: Canon EF 75-300mm at 300mm
Exposure: 0.3 seconds at f45
Filtration: None
Other: ISO 100

Although green is a relaxing colour it can sometimes be slightly boring when shown in isolation. The bright yellows caused by the sunlight prevent this here and the image conjures up memories of warm summer evening walks. **PM**

When faced with an image almost entirely comprised of one colour you could be forgiven for thinking it would be boring. This image proves otherwise – there is far more to this picture than at first meets the eye. The timing was crucial – any earlier and the scene would have been over-lit; any later and the ridges wouldn't have been lit at all. The angle of the ridges within the frame and the positioning of the tree were carefully thought out to create a nicely balanced composition. **CM**

Inspiration: The humble urn is an iconic Greek symbol and makes an excellent subject for an image. Most people would know, instantly, in which country the photograph was made.
The situation: The light falling on the urn came from a street light which would have been programmed to switch off after daybreak. The crucial part of this image was the inclusion of the two curved shadows on top of the wall. When the street lights went out they would disappear.
Camerawork: Camera: Canon EOS 5D
Lens: Canon 24-105mm f/4L IS USM
at 93mm
Exposure: 4 seconds at f14
Filtration: None
Other: Minus 1 exposure compensation,
ISO 50

At first glance, this is a simple image but on closer inspection you can see that a lot of work went into fine-tuning the composition. It required intense concentration but the result was worth it. **CM**

This is one of my personal favourites from all of Clive's work. The lighting is beautiful, the colours are serene and the balance between the curved shape of the urn and the straight lines in the wall and steps is intoxicating. A classically simple image that captures the atmosphere of the location far better than any wide view ever could. **PM**

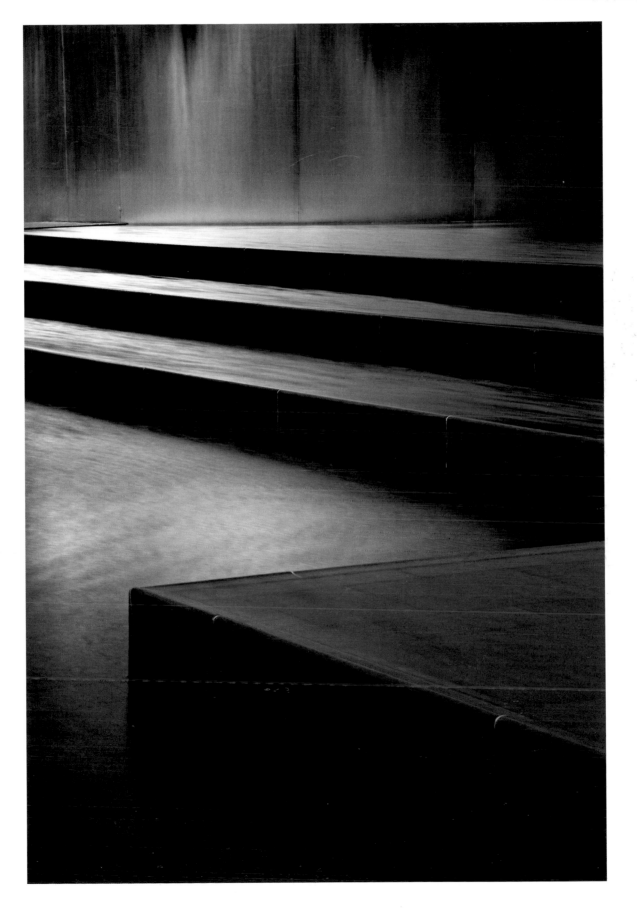

What do you value?

Picture quality shouldn't always be measured in megapixels. What are the values you most want to communicate in your photographs?

p119 Millennium Square
Harbourside, Bristol
Clive Minnitt

p121 River Coupall
Glen Etive, Scotland
Phil Malpas

p119

p121

Inspiration: We all have our architectural preferences. In Bristol, where I live, there is a good selection of Georgian and Victorian buildings, some 1960s monstrosities and some excellent state-of-the-art designs. They are all photogenic, but not all the time. The challenge is to work out when and under what lighting conditions.
The situation: It's hard to believe that this water-feature in Millennium Square is already nine years old. This image was made at 16.45 in mid- December, taking advantage of the lovely light and low contrast conditions.
Camerawork: Camera: Canon EOS 5D
Lens: Canon 24-105mm f/4L IS USM at 40mm
Exposure: 2.5 seconds at f22
Filtration: None
Other: ISO 50

The small amount of afterglow left in the sky plus light falling onto the water feature from the various light sources illuminating the square, have combined to create a subtle array of colours. Mixed light sources have worked well together. **CM**

What Clive doesn't mention is that it was absolutely freezing and required a certain amount of determination to continue photographing! This image demonstrates his ability to simplify. There is nothing here that doesn't belong. **PM**

Inspiration: I have seen (and photographed) this view in a variety of conditions, but here I was really pleased to capture the iconic shape of the mountain during a snowstorm, which rendered it as a ghostly impression of its mighty presence.
The situation: At the head of Glen Etive the River Coupall pours over this small waterfall at the base of Stob Dearg and Buachaille Etive Mor, before joining the River Etive on its short journey to the coast. It is a Mecca for landscape photographers and finding yourself alone here is rare.
Camerawork: Camera: Canon EOS 1DS MkIII
Lens: Canon EF 16-35mm f/2.8L II USM at 27mm
Exposure: 1/5 second at f18
Filtration: 0.6 ND hard graduated
Other: Plus 1/3 stop exposure Compensation, ISO 50

I stood in the water at the base of the fall to change the angle slightly and to avoid too much of the heather in the bottom right of the frame. This lower angle also helps the tree, which from the bank above, would bisect the horizon line. **PM**

This almost monochromatic image contains just a hint of colour. I'm drawn to the subtle shades of brown on the rocks as the water cascades over them. Phil mentions the heather jutting in from the right. I suspect he would be on his way to the sea if he had ventured any further to the left! But I would clone it out for the benefit of a stronger image overall. **CM**

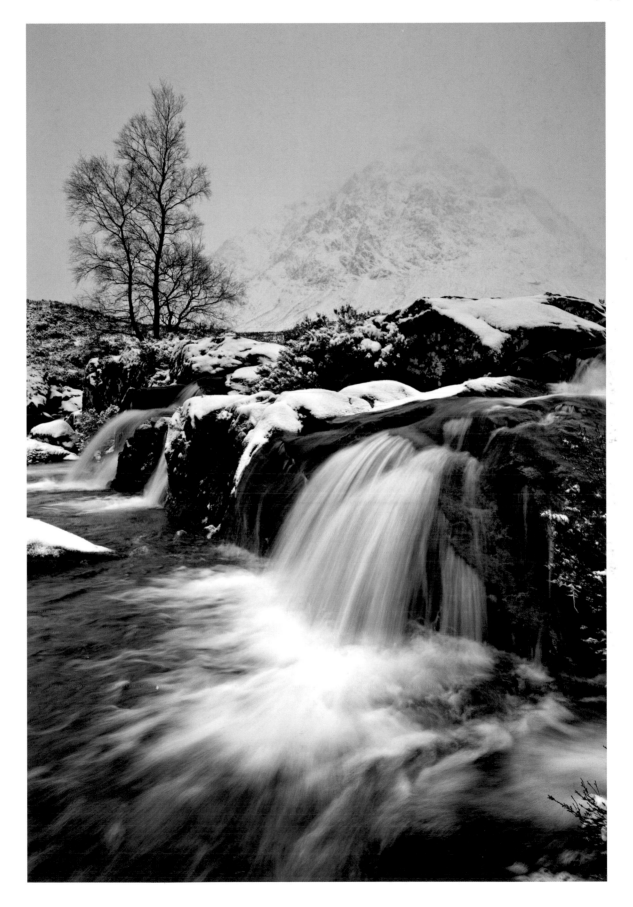

Choosing the right moment

Whether your images are planned or are simply a result of being in the right place at the right time, you will need to decide precisely when is the right moment to press the shutter. Most location photography, whether landscape or architectural, street scenes or simple detail shots, will be affected by changing weather, fluctuating lighting conditions or perhaps the inclusion of one or more moving elements.

The difference between your image having the wow! factor or being one of mediocrity might be slim. For instance, capturing a single ray of sunlight as it falls on the focal point will excite the viewer – a second too early or late and the moment might be lost. Alternatively, a passing cloud may be used to shield the sun and place the subject in the shade, or its shape used to mimic nearby land or sea contours.

When photographing the movement of flowers or trees, grasses, people or vehicles in the landscape, it is important to consider the relationship between them and any static subjects present in the scene. For example, imagine a battered old blue American car parked on the roadside, facing you. As you walk along the pavement towards it you spot a yellow bus parked further along on the same side of the road. The bus driver starts the engine and you sense a good photo opportunity as you imagine the bus passing the stationary car. The complementary colours are striking but the distracting buildings need to be hidden. Good anticipation, considered composition and a speedy reaction might still only give you one chance of achieving the picture you had in mind.

Careful observation of all that is going on around you is the key to anticipating and choosing the right moment to press the shutter. This skill will improve with practice and a greater awareness of your surroundings will help you identify further picture opportunities. Get the timing right and the image will appear crisp and simplified. Pay little or no attention to timing and a far less coordinated image will result.

We all strive for perfection and it is to the photographer's credit when a decision is made to postpone a shoot and return when the light is more appropriate. The highest standards are what we should be aiming for and those pictures that took a great deal of time and effort to achieve are often those we appreciate most. (That said, putting a lot of energy and emotion into a picture can cloud our evaluation of the end result, as to whether it is actually a good picture or not.) **CM**

Knowing when to quit

Success is never guaranteed and it is not an admission of failure to abandon your quest for a particular shot. At times like this, utilise your valuable time wisely and look for alternatives. There will usually be another day to return for a second bite at the cherry.

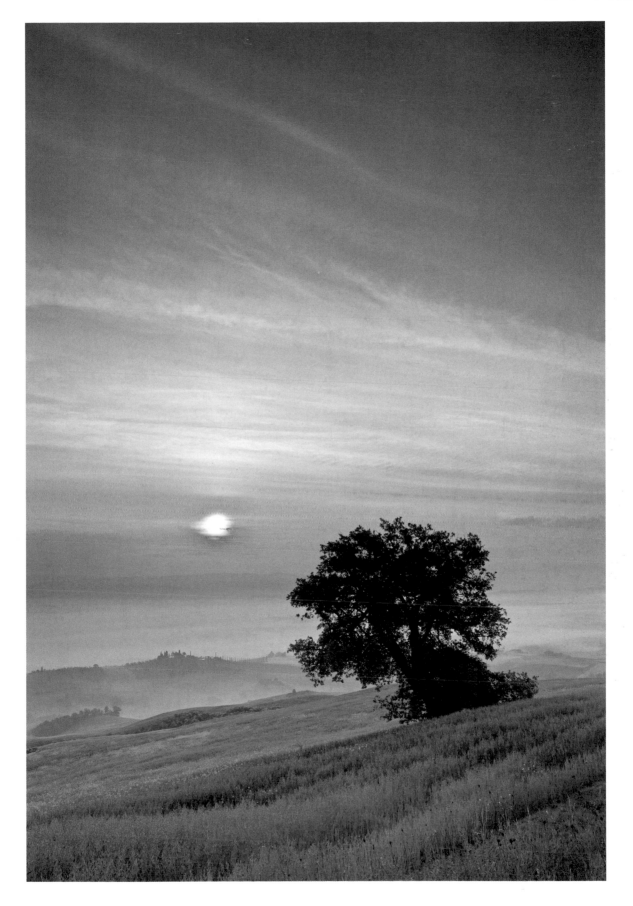

Strive for the best
What is your ultimate aim? How committed are you to this? How many successful photographers have got to where they are without an ambition or a desire to succeed?

p123 **Val D'Orcia**
Tuscany, Italy
Phil Malpas

p125 **Santorini**
Cyclades Islands, Greece
Clive Minnitt

P123

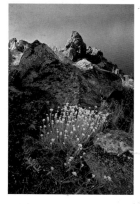

p125

Inspiration: I was initially attracted by the relationship between the patterns in the foreground crop and those in the clouds above the tree.

The situation: This area of the Val D'Orcia seems to experience more misty dawns than any other I have found. There is a wonderful atmosphere at this time of day, with the birds singing and cocks crowing. I hope this image conjures up just some of those impressions.

Camerawork: Camera: Canon EOS 1DS MkIII
Lens: Canon EF 24-105mm f/4L IS USM at 28mm
Exposure: 1/30 second at f16
Filtration: 0.6 ND hard graduated
Other: ISO 200

Careful use of the neutral density graduated filter has allowed me to let enough light into the camera to expose the foreground correctly. This has resulted in a silhouette of the tree but I feel this is an acceptable compromise. **PM**

The mist and low sun has created a calm, relaxed mood. Single trees in the landscape make great focal points – this one has been perfectly positioned within the frame. Another time I will offer to be the assistant and prune the branches at the base of the tree, which are somewhat cluttered – nothing Phil could have done about it! Spotting the excellent relationship between sky and land shows great vision. **CM**

Inspiration: I came across this location during a previous visit. Santorini is a group of islands which once formed a huge volcano. A series of eruptions split the volcano into several islands, allowing seawater to flow into the crater, or caldera. The rim of the caldera provides stunning views. Noting where the sun would rise made me confident that a dawn shoot would give me the best chance of producing an atmospheric image of this rather lofty position above the steep drop into the sea.

The situation: A steep uphill trek before dawn got rid of any lingering cobwebs from the previous night's socialising. Arriving well before daybreak gave me plenty of time to work out my composition before the first rays of light illuminated the rocks at the top of the image.

Camerawork: Camera: Canon EOS 5D
Lens: Canon 24-105mm f/4L IS USM at 32mm
Exposure: 1.6 seconds at f20
Filtration: 0.6 ND hard graduated
Other: Plus 1/3 exposure compensation, ISO 50

My decision to omit the sky was correct as it was featureless and would have been a distraction. With hindsight I think I should have moved slightly to the right so that the brightly lit rock at the top left would have been hidden behind the large rock in shadow. **CM**

Clive's reference to his decision to 'omit the sky' is interesting, because it is only through close study that you realise that the top of the image is actually the sea and the caldera rim. I really enjoy the lack of scale in this image. It is possible to imagine everything from a huge mountain range to a small group of rocks. **PM**

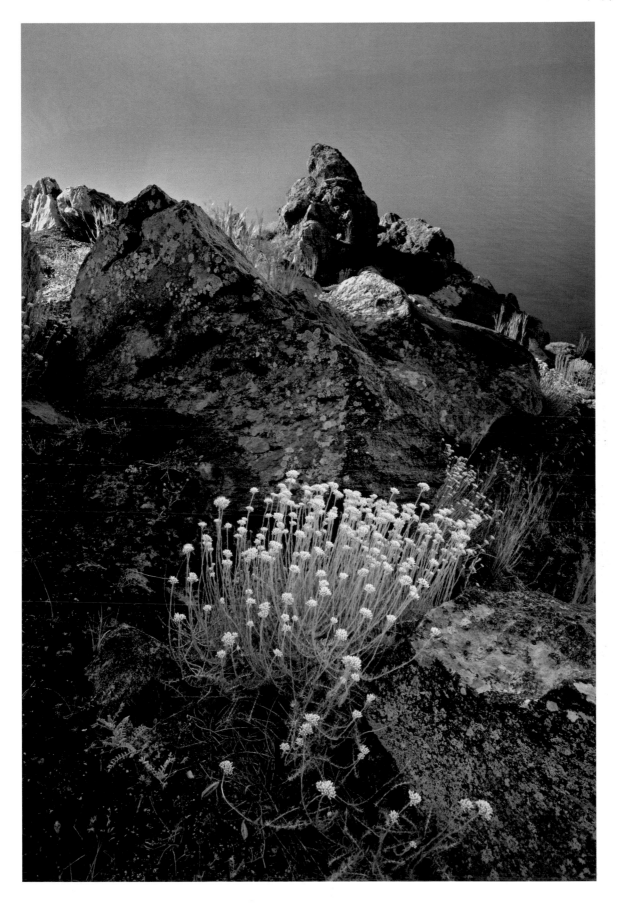

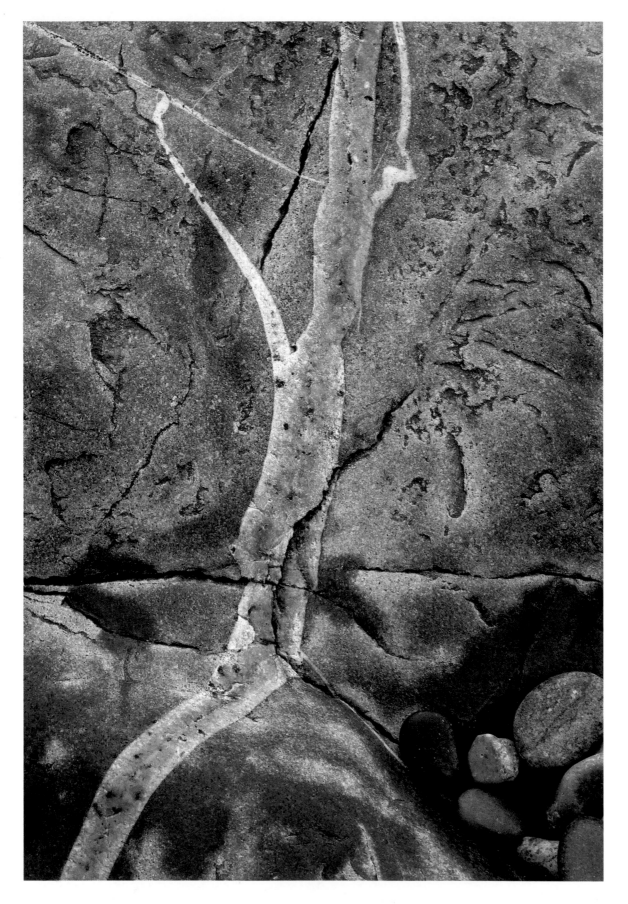

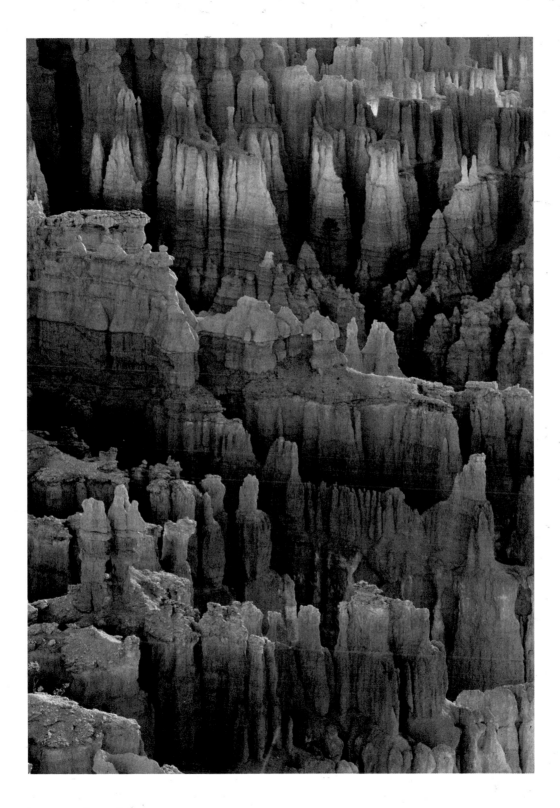

Be adaptable

How quickly can you react to circumstances such as changing light and weather conditions? These may require you to rethink your image at a moment's notice.

Seeking inspiration
Many great photographers have been inspired by artists working in other fields outside photography.

p126 Little Hunter Beach
Acadia National Park, Maine, USA
Clive Minnitt

p127 Bryce Canyon
Utah, USA
Clive Minnitt

p126

p127

Inspiration: I love a compositional challenge and this certainly was one – with a capital 'C'.

The situation: The sun had disappeared behind the cliffs leaving this small cove lying in the shade – perfect! Where to start was the problem, as there was an abundance of possibilities.

Camerawork: Camera: Panasonic Lumix DMC-LX3
Lens: Leica DC Vario-Summicron, 3:2 format
Exposure: 0.5 seconds at f8
Filtration: None
Other: ISO 80

After attempting several times to find a composition that I liked – and failing – I realised it was the inclusion of the pebbles that made a marked difference, the brown ones in particular. However, that wasn't enough! The pebbles had to be positioned in such a way that they added a positive element to the picture rather than detracting from it. Nor should they be too dominant. Even the angle that each pebble sits at is important, and the position of the cluster of pebbles as a whole, in relation to the rest of the image, had to be considered. **CM**

I find Clive's obsession with these pebbles enlightening. They obviously make a significant contribution, but I wonder if there was a composition available without them. What they do add is a sense of scale and I would like to have known if a more ambiguous image might have been an option. The timing was crucial as it was vital that the subject didn't dry out completely. The damp areas add a great deal in the bottom third of the frame. **PM**

Inspiration: This was my first real experience of reflected light and the amazing effects it can create. It changed my way of thinking and caused me to consider the many different forms of ambient light much more carefully afterwards.

The situation: Not surprisingly, at an elevation over 8,000 ft, Bryce Canyon is a little on the chilly side when standing on the rim watching the pre-dawn light. Any discomfort was more than worth it when the sun rose and illuminated the canyon wall below the rim where I was standing.

Camerawork: Camera: Canon EOS 1
Lens: Canon 100-300mm L
Exposure: Settings not recorded
Filtration: None
Other: Fuji Velvia transparency film, ISO 50

It wasn't the naturally illuminated canyon wall which had such an effect on me but the remarkable amphitheatre below it, full of magical sandstone formations known as hoodoos. Light was reflected from the canyon wall onto the hoodoos, making many of them appear translucent. This image accurately portrays the scene and brings back happy memories. **CM**

This is a classic image of the fantastic geological formations in Bryce Canyon. Its success is due to the varying degrees of light in different parts of the image. The tiny lit area in the top right of the frame is important as it serves to prevent the more shaded area from being dominant and giving a top-heavy feel to the composition (try covering it to see what I mean). **PM**

On location:
The Second Severn Crossing

'Yeah, it's just a bridge,' they replied simultaneously, with an air of despondence. I was dumbfounded! They must have had other things on their minds.

It was August and the weather in distant Wales looked inclement to say the least. The International Hot Air Balloon Fiesta in Bristol was all but abandoned due to high winds and rain, so any thoughts of photographing brightly coloured and oddly shaped inflatable objects in the sky was a non-starter. Was there an alternative?

The Second Severn Crossing is just ten miles from my home. It's local and I know the area well. I'd visited it on many occasions and, from experience, was confident it would make a good focal point in these stormy conditions. There are many places from which to photograph it and at 4 pm I arrived at my favourite spot, mid-way between the old and new crossings, near the village of Aust.

I had four hours of the most magical light; one storm after another passed over the bridge and shimmering light reflected off the river. This time I was lucky and remained dry. Every so often a few rays of sunlight poked through the volatile clouds and illuminated parts of the bridge but never the whole. The light reflecting from the supporting stays, which were at right angles to the sun's rays, made it a spectacular scene. I shot several rolls of film – in almost every frame the light was uniquely different.

Instances like this are what every lover of outdoor photography craves – eureka! moments by the bucket load, when a special light brings a scene to life. Such dramatic mood changes (to the landscape and us) are brought about by what some might regard as dreadful weather conditions.

This was the first time I had witnessed such conditions in the Severn Estuary *and* had a camera with me. Thank goodness I had taken my tripod as the conditions were far too dark to hand-hold the camera.

Towards the end of this wonderful natural light show, I had noticed a couple ambling along aimlessly. Making sure I didn't take my eye off the bridge or my hand off the cable shutter release, I pointed to the beautifully illuminated bridge and excitedly asked them – 'have you seen that?' **CM**

Working with mixed light
It is simplest to start with just one natural source of light at a location, but with practice you can learn to choose subjects that employ mixed lighting, direct and reflected, which may add interest to the scene in terms of contrast and colour variation.

West Woods, Wiltshire, England. **PM**

Extreme lighting conditions
How do we handle the strong overhead light that occurs in the middle of the day? One option is to photograph close-up details contained within shadow areas of the scene.

So, what next?

**What have you learned? | On location: Les trois chateaux |
An informed approach | Invite feedback | On location: 'On Location'**

No matter how experienced we become as photographers, there will never come a point when we know it all. There is always something new to learn, someone else to learn from and somewhere or something different to focus our lenses on.

David Ward was recently asked what his favourite location was and he replied 'The one I am in at the time'. This is a good attitude to have because it implies that, wherever you are, there will always be opportunities for photography and the best bet is to look for them where you are. Constantly wishing you were in another, more spectacular location isn't going to make great pictures for you. Clive's image of St. Andrews Park on page 39 shows how a little local investigation can lead to great results.

A question we are often asked is, 'What is your favourite picture?' The best answer to this is surely, 'The next one I take.' It is surprising how our older work, which we thought was fantastic at the time, can be less appealing when we revisit it later in life. This is because we all move on and that constant improvement is what prevents photography from ever becoming boring. So remember that: the next time you press the shutter you might just take your favourite picture. **PM**

What have you learned?

If you want to improve your photography it is important to constantly assess your progress and to apply a healthy dose of self-criticism to your work. If a shoot or a project doesn't turn out well, try to analyse why and learn from your mistakes. Perhaps your composition wasn't tight enough and you left some elements in the frame that didn't contribute to the final result. It may have been that the light just wasn't special enough or that your image would have worked better at a different time of day.

Equally, when something goes well, give yourself a pat on the back and see what you can learn from this. Success breeds confidence, which breeds more success. By consistently making the effort to get feedback you will soon notice an improvement in the quality of your images. One of the dangers of digital photography is that because there is no cost involved in taking pictures there is a temptation to take lots of them. It then becomes difficult to invest the time required to study the results and assess their quality. This is the modern-day equivalent of putting your prints in a drawer and forgetting about them. A mass of digital images gets filed away on a hard drive never to be seen again. This is where one of the library programs such as Adobe Lightroom or Apple Aperture can help. These programs encourage you to assess, evaluate and grade your work. If you have multiple copies of similar images, they offer tools that help you to select the best ones. As you work through all the images from a specific location you can build up collections of your favourite pictures and access these quickly and easily.

Of course, if you are going to invest time and effort in sorting and cataloguing your work you will need to identify your personal criteria for assessing your success. Ultimately you should make your photographs to please your number one critic – yourself. There is immense satisfaction to be gained when you find that you have captured something very special. After all the practice, study and effort you realise that it has all been worth it. However, beware of allowing your opinion of an image to be influenced by the effort that was involved in obtaining it. If you had to get up before dawn in the freezing cold and carry your camera bag up a mountain, all before pressing the shutter, there is a temptation to grant that image more than its fair share of merit. **PM**

Gaining momentum
We all draw strength from our successes. As your picture finding and capturing skills improve you will enjoy being swept along in a glorious wave of enthusiasm and an eagerness to improve still further. But, as the quality of your photography improves your ideas will also need to develop. Try working on a personal project, returning to the same subject over a period of time.

It's all in the preparation

There are many different aspects to preparation: practical, theoretical and mental. Photography relies on a working combination of all of them.

p133 Vinales
Cuba

Phil Malpas

p135 Afissos
The Pelion, Greece

Clive Minnitt

p133

p135

Inspiration: It was the chair that first caught my eye; it was so unusual, and so obviously well used. How many happy hours had been spent watching the world go by from the comfort of this little chair?

The situation: It was important that I gained the maximum height for my camera on the tripod to prevent converging verticals and also so that I could see the bottom of the yellow door above the right arm of the chair. I worked hard to find my viewpoint as there were also a few cables to the right and a switch to the left that I needed to exclude.

Camerawork: Camera: Canon EOS 5D
Lens: Canon EF 28-135mm f/3.5-5.6 IS USM at 47mm
Exposure: 1/60 second at f9
Filtration: None
Other: ISO 400

This is a classic case of being attracted by complementary colours. Blue and yellow offer maximum colour contrast. I really enjoy the timeless simplicity of this image. **PM**

Simplicity works! I find this uncluttered picture very powerful. The strong diagonal leads the eye from the chair to the shutters. There is a further relationship between the wooden back-rest on the chair and the window. If any additional elements were introduced the balance would be lost. **CM**

Inspiration: I fell in love with this scene as soon as I had twigged what was going on. It had the potential to make a strong image and wasn't something you saw every day.

The situation: It was a bizarre scene. The wall had been built around the tree and Mr Walter Whitewasher had simply applied his brush in a continuous way – as if he was oblivious to the fact that the tree existed.

Camerawork: Camera: Canon EOS 5D
Lens: Canon 24-105mm f/4L IS USM at 24mm
Exposure: 1/80 second at f8
Filtration: None
Other: Hand-held using image stabiliser, plus 2/3 exposure compensation, ISO 400

Whenever I look at this image it fascinates me. I imagine I'm seeing human and animal life forms amongst the folds of the trunk. The green and brown leaves at the base confirm that the tree is living. **CM**

Clive has a talent for finding pictures where others struggle. At first glance this seems a simple image, but once you begin to study it you find new layers of complexity. I love the subtle nature of the colour in this almost monochrome composition. **PM**

Who said it's easy?

At times photography can be frustrating: the light is fantastic, the subject's ideal, but no matter how hard you try you can't make your composition work. There are too many compromises. It isn't for lack of effort or trying every conceivable angle – it simply doesn't work. Time to abandon, look elsewhere and find another location!

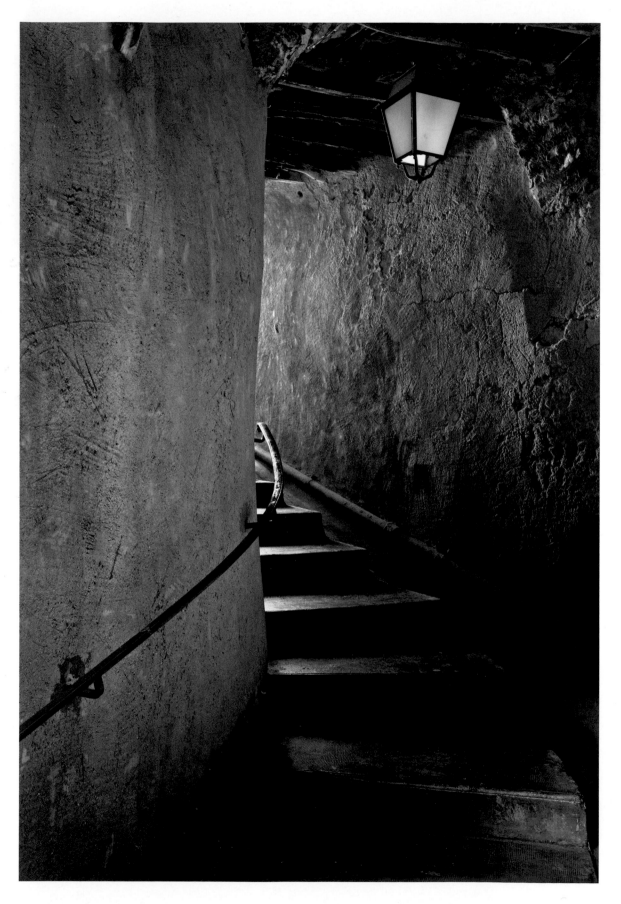

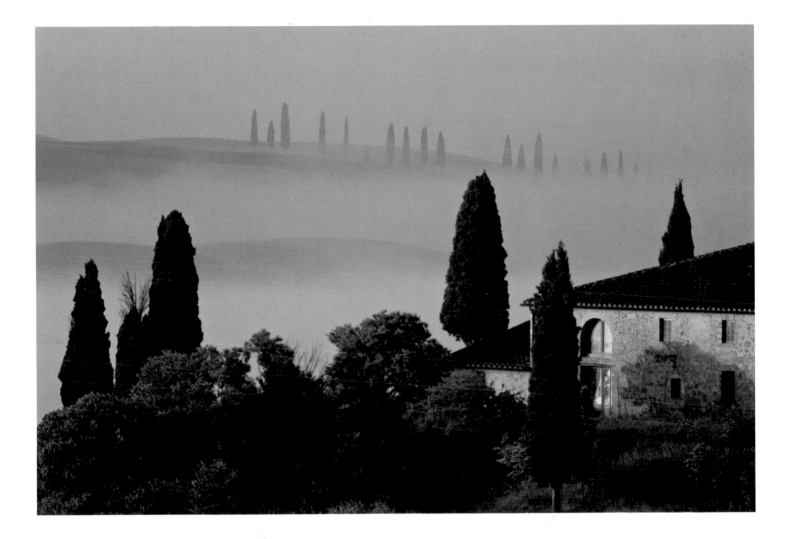

The best vantage point
Photograph the same subject from a dozen different viewpoints. Shoot from a lower position and also higher, using a stepladder if necessary. What effect does each viewpoint have on the subject and are some more successful than others?

Go with the glow

During twilight (pre-dawn glow) and after sunset (afterglow) the light levels are often deceptive and should be ample for moody images, even without raising the ISO setting on your camera.

p136 **Rousillon**
Provence, France

Phil Malpas

p137 **Belvedere**
San Quirico d'Orcia, Tuscany, Italy

Clive Minnitt

p136

p137

Inspiration: This delightful staircase and arch is close to the centre of the ochre-coloured village.

The situation: Some precarious tripod positioning was needed to get my camera into this position where I was able to hide the odd unsightly electricity cable.

Camerawork: Camera: Canon EOS 5D
Lens: Canon EF 17-40mm f/4L USM at 36mm
Exposure: 15 seconds at f16
Filtration: 0.3 ND hard graduated
Other: Minus 1/3 stop exposure compensation, ISO 160

I am pleased with the effect caused by my white balance selection, which has allowed the early morning daylight coming from the top of the stairs to give them a distinct blue colour. This creates a nice contrast with the red walls. **PM**

Lovely use of variations of the complementary colours blue and yellow. There is no harsh light falling on the scene – it is being edreflected from walls just around the corner, giving a much softer effect. Phil's experience helped him to see a picture that many would pass by. **CM**

Inspiration: There have been many wonderful images made of this iconic Tuscan landscape. How would I photograph it any differently?

The situation: When I looked at the work of others the first thing I noticed was that the photographs were generally wide-angle. Perhaps I should try a close up? The dawn was stunningly beautiful and inviting.

Camerawork: Camera: Canon EOS 5D
Lens: Canon 100-400mm f/4.5-5.6L IS USM plus 1.4 converter at 560mm
Exposure: 0.4 second at f20
Filtration: None
Other: Plus 1/3 exposure compensation, ISO 50

I think a tight composition works well. I had to consider the positioning of the foreground cypress trees against those behind. **CM**

I've been fortunate to spend countless dawns at this special location, and yet it has never occurred to me to photograph it in this way. I should learn to practise what I preach and consider all my options. Clive has managed to show us a new perspective on a much-photographed subject. This is something we should all strive to achieve. **PM**

On location:
Les trois chateaux

Two books that have inspired Phil and I are *The Making of Landscape Photographs* and *Seeing Landscapes*, both of which were written and photographed by Charlie Waite. In both titles the standard of photography is exceptional and the locations stunning.

Soon after the second of these books was published, Phil and I devised a cunning plan. We were due in Provence, to join a photography tour led by Joe Cornish and David Ward, and needed a bit of adventure en route. We conspired to emulate Charlie Waite and visit some of the French locations that he'd photographed and included in his books.

Our plan was not to copy his images (as this would be virtually impossible) but to see if we could understand Charlie's approach, and create our own images, hopefully with the same breathtaking impact. The timescale was a bit tight, but adequate for our planned visits to three impressive chateaux in the Loire Valley. Phil and I arrived, tired but full of anticipation, especially having been given hearty encouragement by the man himself. He was excited to see how we would approach the same subjects and we promised to meet up with him on our return for a debrief. We were confident that photographing les trois chateaux would be a piece of cake.

How wrong we were! The first chateau resembled a builder's yard and was covered in scaffolding. At the second, a tree, which was to play an important part in the compositions we had in mind, had been cruelly struck down by lightning. The third required an hour-and-a-half's drive to reach it, and having got there in time for the break of dawn at 6 am, we discovered that the gates were locked and didn't open until 9 am!

Continuing our route south, we chose to stay overnight at a village called Loubersac, which Charlie had kindly recommended. It is one of the locations he visits when leading photographic tours to the Dordogne and is one of the most beautiful villages in France. When we arrived we were a little concerned as to Charlie's choice of 'idyllic', photogenic village. It was an uninteresting place to say the least.

We soon realised our mistake – we should have been in *Loubressac* in the Lot region. Loubressac was *very* photogenic! Our inexperience showed and our poor planning and lack of forethought let us down badly. We quickly learned from our mistakes and had a few laughs with Charlie when we returned – we had to admit to having no interesting pictures of the chateaux! **CM**

Ideas on a postcard
When researching a new location, in addition to looking at travel guides and pictures on websites, seek out boring-looking postcards in local newsagents and gift shops, and study them carefully. They are often more helpful for ideas than stunning photographs of the same place.

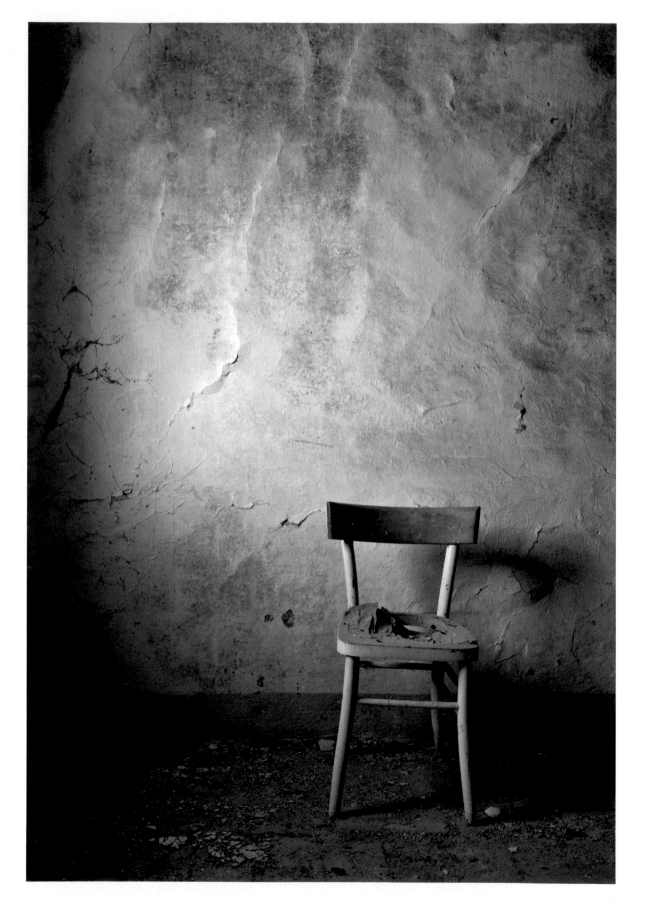

An informed approach

There is always something new on the market that is heralded as the next big thing in photography. Whether it's a new camera, an innovative piece of software or an improved film stock it is difficult to resist the feeling that it might be just the thing you need to elevate your work to the next level. Keeping up with the latest developments can be an expensive exercise and no piece of equipment is going to deliver a miraculous solution. Having said that, it is always worth keeping an eye on the photographic press and the Internet or attending trade shows in order to stay informed of new developments.

If you have started to build up a good selection of images you may want to share them with the world. There are many simple options for building your own website, which is a great way to get feedback on your work. It is immensely satisfying to receive an email from some far-flung corner of the world sent by someone who admires your images. Even if you don't feel confident enough to take this step, it is worth thinking of a suitable web address and reserving it for when you do.

Having a website will also sharpen your critical skills by making you assess whether new work is of a high enough standard to put online. You may even find that you have a talent for web design and produce something really innovative to showcase your photographic talent.

One way to stimulate creative output is to take yourself out of your comfort zone and try a completely different approach to the one you are familiar with. You could have a go at pin-hole or macro photography, for example, or try working in a different format, such as large-format film photography, which is becoming increasingly popular as well as affordable. Alternatively you could consider having a digital camera converted to shoot infrared. Experimentation of any sort is never wasted effort and you may come up with a groundbreaking idea that no-one else has thought of. **PM**

Overcast days

Overcast days are excellent for photographing detail. Interiors of buildings, rocky shores (otherwise deeply shadowed), and woodlands are ideal subjects to save for a grey day, when there is less contrast. Wet weather days are good for photographing tumbling streams and waterfalls.

The waiting game

Waiting for the clouds to be in a better position or for a shaft of light or a shadow to fall on part of the scene can make all the difference to a photograph.

p140 **Cosona**
Tuscany, Italy

Phil Malpas

p140

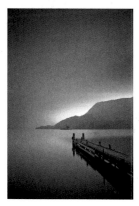

p143

Inspiration: I was attracted by this little chair, which I photographed exactly as I found it. Its position under a window to the left placed it in beautiful light and although the rest of the room was exciting I decided to focus on this small detail.

The situation: This abandoned farm was a goldmine of opportunities. Care was needed though as the structure was far from sound. In fact on a recent visit we were saddened to find that it had been boarded up after one of the ceilings collapsed.

Camerawork: Camera: Canon EOS 5D
Lens: Canon EF 17-40mm f/4L USM at 40mm
Exposure: 5 seconds at f16
Filtration: None
Other: ISO 50

This is a very simple picture, something I strive for. I love the palette of pastel colours and the way the viewer's attention is focused on the chair by the light from the window. The damaged seat helps to provide a sense of history and makes me wonder what momentous events this chair might have witnessed. **PM**

Composition is a very personal thing and I might have approached this differently, positioning the chair (in the viewfinder) either centrally or to the left of centre, to allow me to see more of the shadow cast on the wall. Who says decay and debris are unappealing – a week spent in this building would not have been too long. **CM**

p143 **Ullswater**
The Lake District

Phil Malpas

Inspiration: My inspiration was an image made by Light & Land client Jonathan Horrocks, which was awarded Image of the Month in 2006. So popular is Jonathan's image that others have begun to refer to this as 'Jonathan's Jetty'.

The situation: This jetty sits in the grounds of The Inn by the Lake in Glenridding and is one of three or four that are perfectly placed to greet the dawn. I wanted to emphasise the peace and tranquility and elected to use a 10 stop ND filter, which allowed an exposure of roughly two and a half minutes.

Camerawork: Camera: Canon EOS 1DS MkIII
Lens: Canon EF 24-105mm f/4L IS USM at 24mm
Exposure: 148 seconds at f11
Filtration: 10 stop neutral density
Other: ISO 50

This image is all about mood. Although it might be described as sombre, I find it tranquil and relaxing to look at. The 10 stop filter causes the camera to add a small amount of false colour, something I find exciting as the precise results are somewhat unpredictable. **PM**

Although using a long shutter speed is a well-practised technique, the use of a 10 stop neutral density filter was a step into the unknown. With Phil's digital camera it takes as long to write the file away to memory as it does to expose the frame. I've yet to be convinced that it adds rather than detracts from the image. **CM**

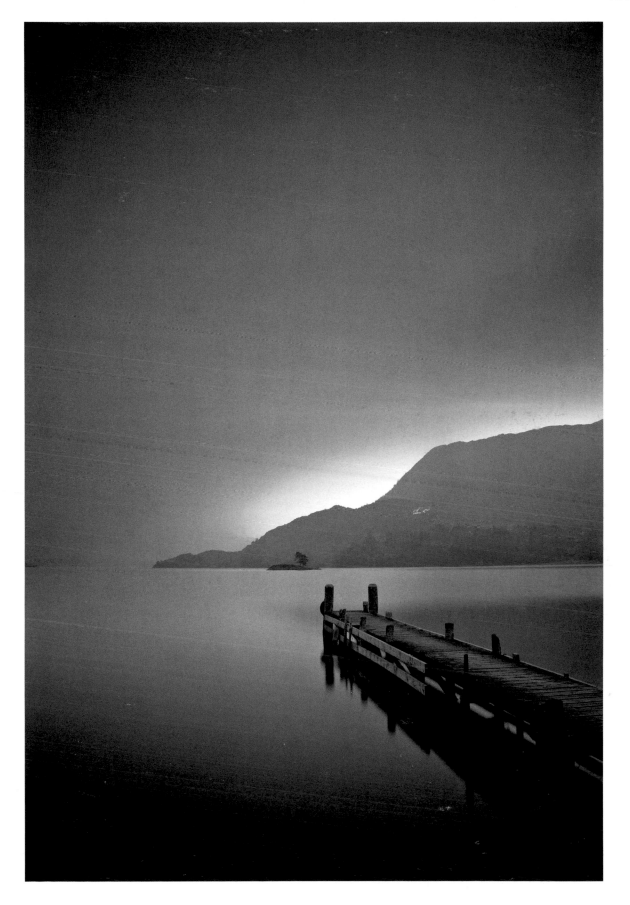

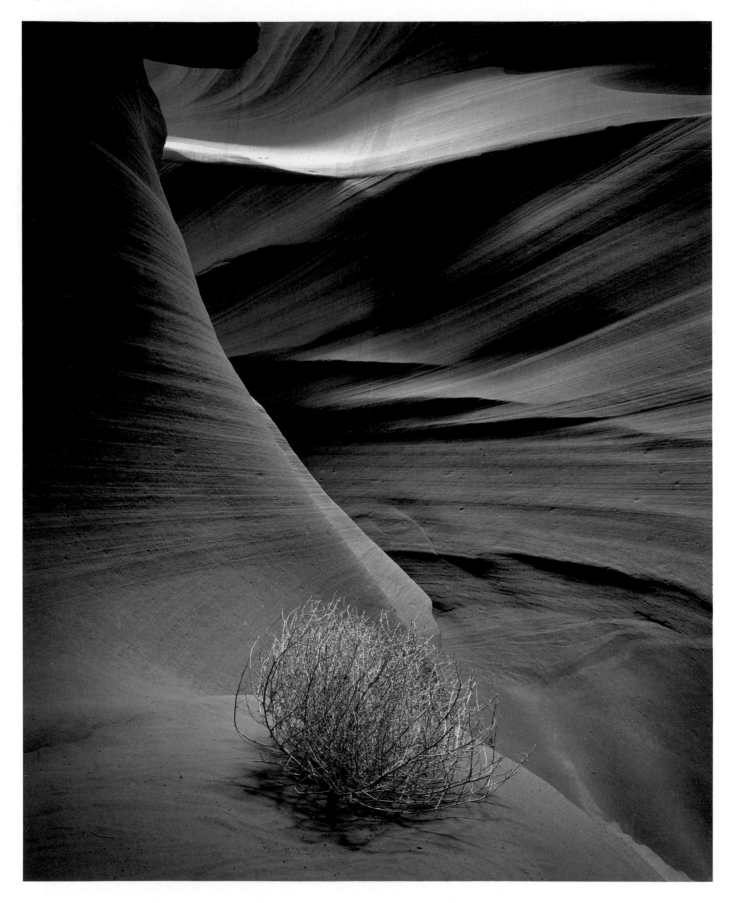

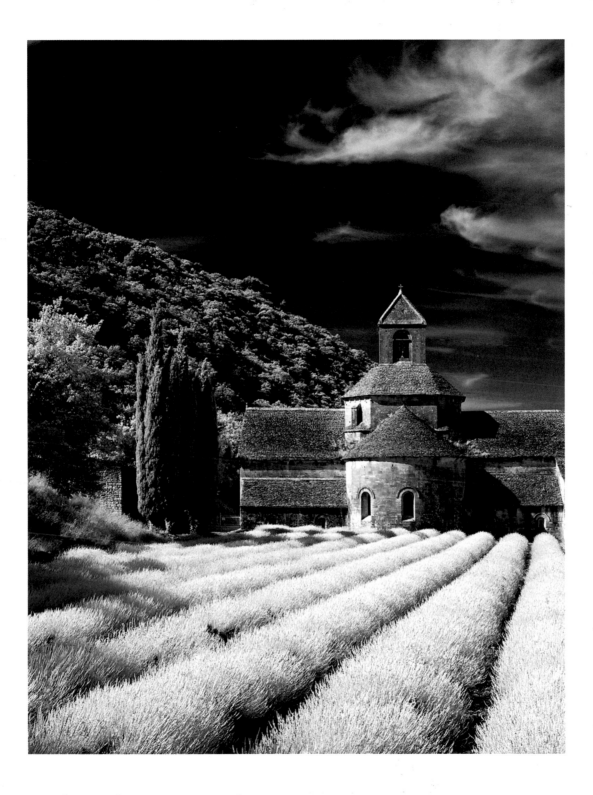

An alternative approach
Try shooting in black and white and exploit the contrast, tones and textures that may appear too extreme in a colour photograph.

Be prepared
Arguably, good anticipation is a better tool than any computer-generated effect.

p144 Lower Antelope Canyon
Arizona, USA

Phil Malpas

p144

p145

Inspiration: I made this exposure during the first of my two visits to lower Antelope Canyon. It took me a while to spot the tumbleweed on an upper shelf, but once I had, I knew there was a successful composition to be uncovered.
The situation: I was standing on a shelf just above the entrance to the canyon. Other people entering would have to cross behind the tumbleweed so I had to shout and ask people to wait during each 45 second exposure (I exposed 7 separate sheets of film). No filtration was required and the wonderful colour is simply down to Fuji Velvia, the long exposure and of course the light!
Camerawork: Camera: Ebony SV45TE
Lens: Schneider APO Symmar 150mm f/5.6
Exposure: 45 seconds at f32
Filtration: None
Other: Fujichrome Velvia Quickload, ISO 50

This has been one of my most successful images and yet it just seemed to fall into my lap! The tumbleweed is photographed where I found it. It seems to add an extra dimension to the carved sandstone of its unique environment. **PM**

A classic slot canyon image and one of the best I have seen. This image shows superb use of texture, colour, light, composition, balance, patience and an ability to spot something out of the ordinary. **CM**

p145 Sénanque Abbey
Near Gordes, Provence, France

Clive Minnitt

Inspiration: Bright sunlight falling on the lavender, gorgeous clouds and a rich blue sky. The first thing that sprang to mind was infrared.
The situation: It was almost panic stations – experience told me that clouds don't hang around for long. I wanted to retain a space between the clouds and the top of the Abbey tower, and the clouds were moving swiftly from the right.
Camerawork: Camera: Canon Powershot G1
Lens: Compact
Exposure: 0.5 second at f4.5
Filtration: R72 infrared
Other: Minus 2/3 exposure compensation, ISO 50

This is one of my favourite infrared images and was great fun to make. I was helped enormously by having perfect conditions for the subject. **CM**

Here is a subject that screams infrared and Clive did well to spot its potential. Remember, all infrared light is invisible to us and so potential compositions have to be entirely imagined prior to capture. As he rightly points out, the cloud is crucial here. If there hadn't been any cloud present I'm sure he wouldn't have taken this picture. I wonder if the cloud moved further into the frame, without appearing to touch the abbey roof? **PM**

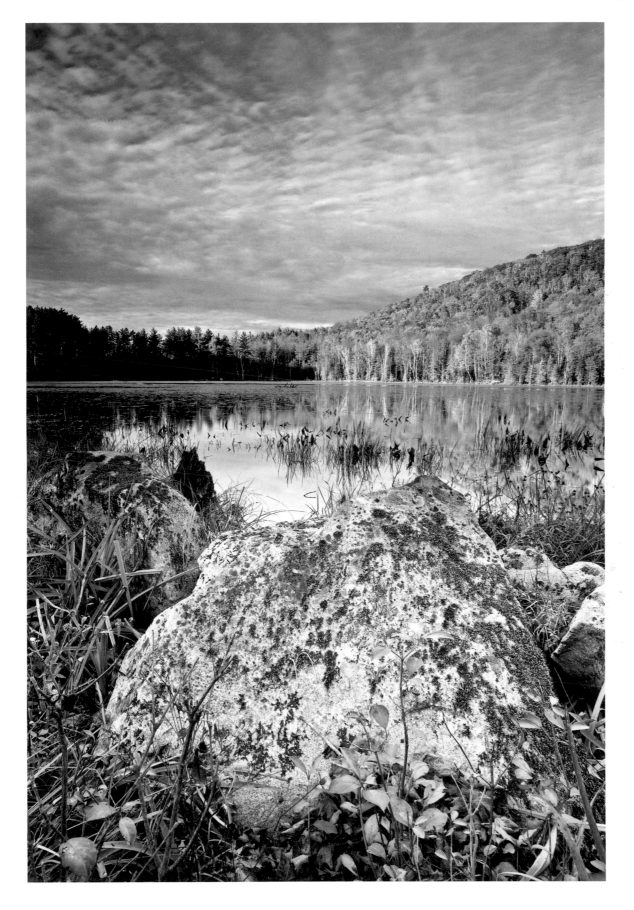

Learning from the professionals

Drawing on the experience of professional photographers, for example by working as an assistant, is an excellent way to learn the technical aspects of the subject, but having done so it is important to develop your own style.

p147 Bailey Pond
Vermont, USA

Phil Malpas

p149 Pentireglaze Haven
Cornwall, England

Phil Malpas

p147

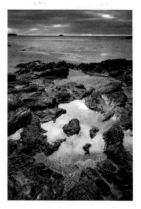

p149

Inspiration: This small pond was recommended to us by the owner of a local cake shop. He was a real character and I could never be sure if he was being entirely honest. On this occasion he came through with flying colours and this is now one of my favourite locations.

The situation: On arrival the sky was completely clear, making composition difficult. After about an hour this cloud arrived, which helped somewhat, although I still needed help from a polariser and a neutral density graduated filter to allow enough light into the foreground.

Camerawork: Camera: Canon EOS 5D
Lens: Canon EF 17-40mm f/4L USM at 20mm
Exposure: 5 seconds at f22
Filtration: 0.3 ND hard graduated, polariser
Other: ISO 50

It is just possible to see where the ND grad clips the top of the foreground rocks and even then the reflection of the sky in the water is slightly brighter than the sky it is reflecting – never ideal. Even so this is one of my favourite images from many visits to Vermont in the fall. **PM**

It is exhilarating observing rapidly changing conditions and having to react quickly to whatever nature throws at you. I agree with Phil, a bland blue sky would have made the foreground rock appear too dominant. The mottled cloud has made the picture much more meaningful, working in tandem with a similar effect on the large rock. Being prepared is hugely important. A picture worth rewarding with a cake. **CM**

Inspiration: Some friends had kindly allowed my partner Rachel and I to spend a glorious week in their house in Polzeath. By way of thanks, I decided to give them a framed print of an image I made that week and this was my offering.

The situation: Conditions were changing rapidly as the sun dropped quickly below the horizon. A second image, taken immediately after this, had none of the wonderful light reflected in the foreground rock pool.

Camerawork: Camera: Canon EOS 5D
Lens: Canon EF 17-40mm f/4L USM at 33mm
Exposure: 2 seconds at f22
Filtration: 0.6 ND hard graduated
Other: ISO 100

This was a classic case of finding an interesting foreground to place in front of the main subject. I had wanted to photograph the view towards Gulland Rock at sunset, and this little rock pool with its lovely coloured rocks and interesting reflection made the composition come alive. **PM**

Not accepting second best is a good strategy to employ. Phil spent time scouring the beach until he found the most suitable foreground to use in his composition. A case of experimenting until something clicks. **CM**

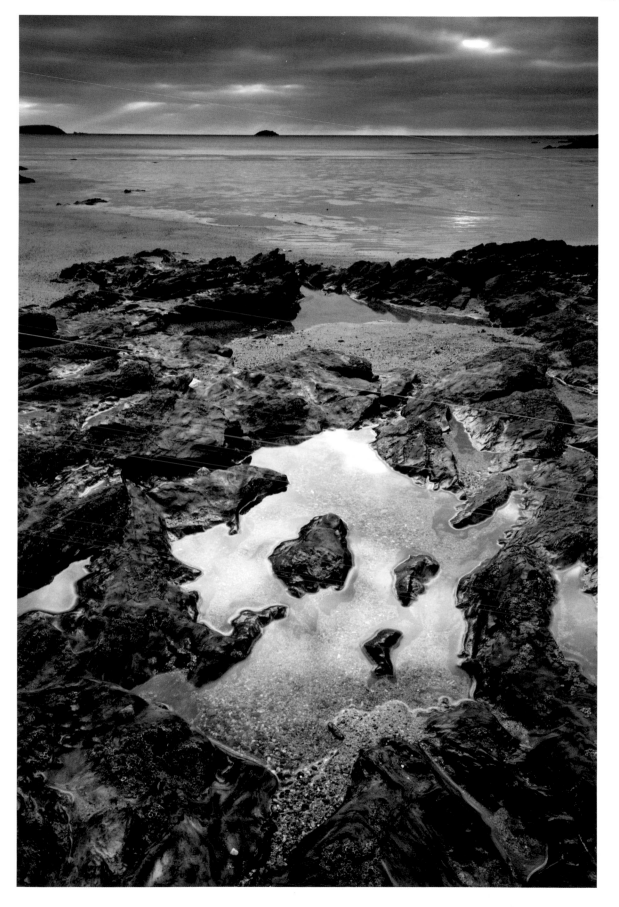

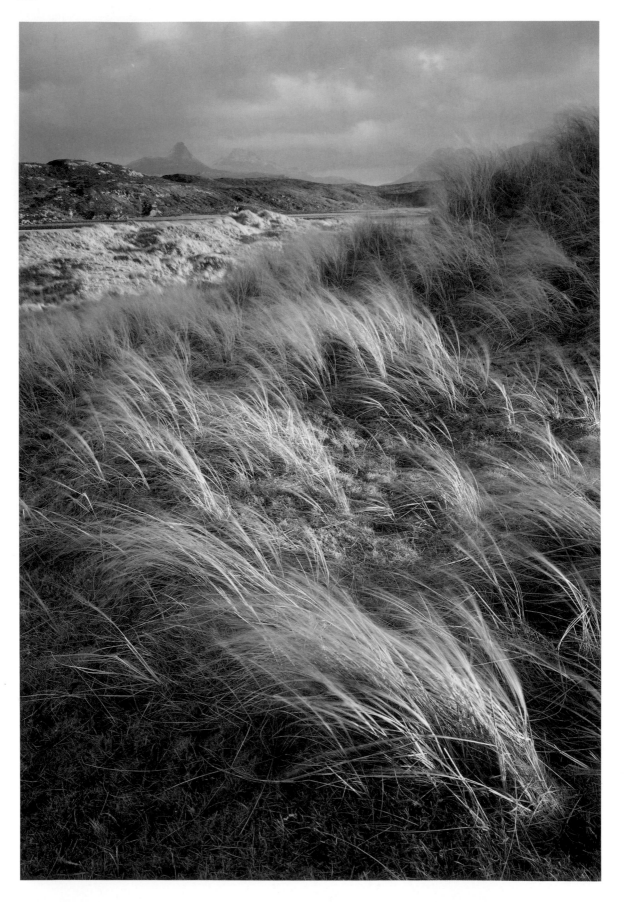

Invite feedback

Photography is definitely an example of an endeavour that requires a large amount of perspiration and just a little inspiration. The only way to improve your image making is to practise, practise, practise, and then practise some more. In order to assess your progress, you need feedback, and this can come from several sources. Firstly there is your own personal assessment of your results. As you become more experienced, you will recognise that your standards move ever upwards. The more excellent the results you achieve, the less likely you will be to accept the average ones.

The second level of feedback comes from friends and family, who will usually have a biased view in your favour. The third level of feedback comes from members of the public who see your work, and who will assess it purely on its merits. One great way to get feedback from total strangers is to make and sell your own greetings cards. Many small independent shops will be more than happy to sell the work of a local photographer, particularly if you have images of local scenes. The sales figures you get from the retailer will be a great indicator as to which of your images are appreciated above the others. Another increasingly popular way to showcase your photographs is to design and print your own book. There are many websites that offer this service at very reasonable prices, and some allow you to market your masterpiece to the entire world!

The fourth and possibly most intimidating source of feedback is, of course, your fellow photographers. If you visit a photographic exhibition you can be sure that the individual with their nose two inches from a six foot square print is a photographer checking for sharpness. Try to gain feedback from your fellow photographers as often as possible, perhaps by joining a local camera club or attending a photographic workshop. Don't be put off by any criticism you receive, keep an open mind and don't be frightened to disagree if you feel the criticism isn't justified.

All this feedback is extremely useful as you can use it to assess the progress of your image making. Even the masters of photography crave this recognition. Of all these types of feedback, that which you receive from your fellow photographers is likely to be the least beneficial. If this is less than complimentary there may be some hidden agenda. Perhaps your critic regrets that they weren't the one to find the picture! **PM**

Know your filters

Knowing which filters to use and when will greatly add to your armoury of picture-making skills. Neutral density (ND) graduated filters are used to reduce the brightness of part of an image – typically the sky – to allow the remainder of the image to be correctly exposed. Non-graduated ND filters are used in extreme lighting conditions to reduce the amount of light reaching the sensor or film to a manageable level. Note: if you can see a photograph has been filtered then it hasn't really worked.

It's all about light

The quality of light will affect the way a subject is portrayed and how a picture is interpreted by the viewer.

p150 Stac Pollaidh
Ross-shire, Scotland
Clive Minnitt

p153 Zion Canyon National Park
Utah, USA
Clive Minnitt

p150

p153

Inspiration: Ever since I walked from Glasgow to Scotland's north-west coast at Cape Wrath during the 1980s (admittedly in three sections) I have been keen to return and complete my first trek to the summit of Stac Pollaidh. Unfortunately, on this occasion inclement weather put paid to the best laid plans again. The next attempt will be something to look forward to with great anticipation.
The situation: The iconic mountain, Stac Pollaidh, was too far away for me to do justice to it, even when using my longest focal length lens. My best option was to use the gentle curve of the highlighted grasses to lead the eye towards the distant mountain.
Camerawork: Camera: Canon EOS 5D
Lens: Canon 24-105mm f/4L IS USM at 35mm
Exposure: 1.3 seconds at f22
Filtration: 0.6 ND hard graduated
Other: Plus 1 2/3 exposure compensation, ISO 50

Although a volatile sky and wind-blown grasses suggest an angry picture, I find the mood is peaceful and calming. Perhaps it's the warm low light that makes the difference. **CM**

I also made an image I was pleased with here – right up until the point when I saw Clive's! The selective light and shadow in the foreground is spectacular and the band of sunlit grasses in the middle distance is vital (try covering them up to see what I mean). This image shows how the focal point (Stac Pollaidh) can be very small and indistinct in the frame and yet still have incredible impact. **PM**

Inspiration: In an area of remarkable scenery, I was lucky to be in the company of some great mates who are brilliant photographers. It was not difficult to be inspired.
The situation: After an epic trek along a tough trail I had to abseil down a rock using a few old bootlaces and lie flat on my back to make this image. The curved rock in the right-hand top corner was only inches above my head, and the tree some 30 metres away.
Camerawork: Camera: Canon EOS 1
Lens: Canon 17-35mm L USM at 17mm.
Exposure: Settings not recorded
Filtration: None
Other: Fuji Velvia transparency film, ISO 50

Almost all the light is reflected, giving a soft, warm feel to the image. The tiny, delicate tree was included to provide a suitable end point for the long diagonal line of rock, and also, to give the viewer a sense of scale. **CM**

This was a truly great day and this is a suitably special image to remember it by. I do remember Clive lying down to take this image – I just thought he was having a kip after the efforts required to get here! Placing the focal point in the very corner of the frame is a great compositional tool, something we should all experiment with when the subject matter co-operates. **PM**

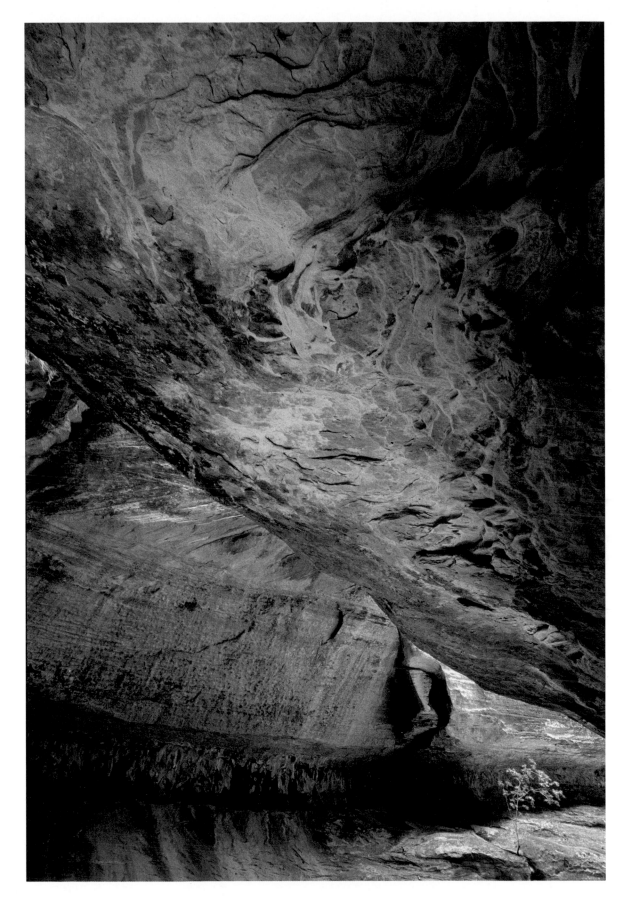

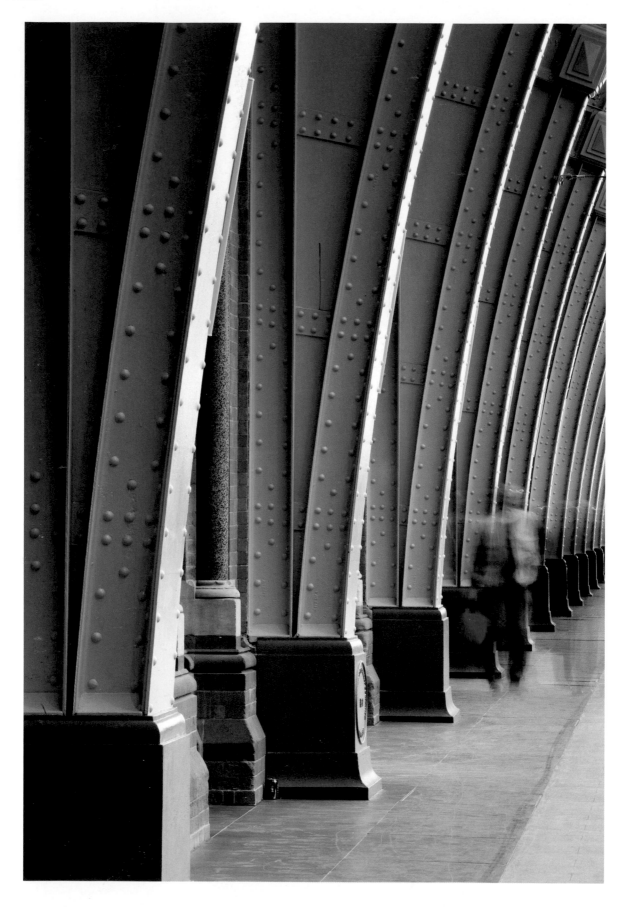

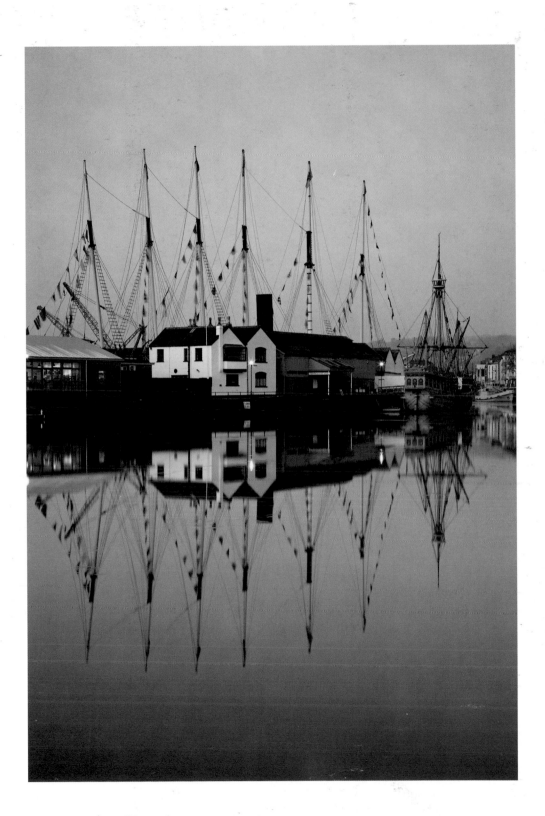

Capturing movement
*Try photographing movement using a range of different
shutter speeds and analyse which image works best.*

A feeling for what's right

Knowing when something is worth photographing, or when a photograph works, is often a feeling, coming more from the heart than from the head.

p154 St. Pancras Station
London, England

Clive Minnitt

p155 The Floating Harbour
Bristol, England

Clive Minnitt

p154

p155

Inspiration: I am rather partial to architectural subjects. St. Pancras had recently undergone a massive reconstruction to restore it to its former glory. The sense of space is immense, and the architectural detail invites the photographer who enjoys working with geometrical shapes.

The situation: At first, the curved ironwork seemed to tick all the boxes in terms of a suitable subject. But on its own it lacked something. The light was excellent, but it wasn't enough. The sudden appearance of a man walking into the scene, carrying an interestingly coloured bag, made a huge difference.

Camerawork: Camera: Canon EOS 5D
Lens: Canon 100-400mm f/4.5-5.6L IS USM at 180mm
Exposure: 5 seconds at f32
Filtration: None
Other: Minus 1 exposure compensation, ISO 50

A long exposure has helped to generate movement in the picture. I decided not to remove the small can from the base of one of the pillars – it adds an element of intrigue. **CM**

The length of exposure here was critical to ensure that the figure had sufficient substance. I find Clive's decision to leave the can interesting, but have absolute faith that it was a conscious one and not something he spotted after he had made the picture! I wonder if it might have been possible to move slightly left and hide the grey pillar, thereby simplifying the overall colour scheme. **PM**

Inspiration: A local florist has purchased my photographic greetings cards of local scenes for a few years. Customers had been asking for a card showing the *SS Great Britain* and the *Matthew* boats together in the Floating Harbour. For one reason or another I hadn't got round to providing one. I have become good friends with the couple who own the florist, Jane and Barry, and was considerably moved when Jane recently developed a serious illness. It struck me as being the ideal time to photograph the boats and produce the card they had requested. I presented it to her as a 'Get Well' card.

The situation: On this occasion I had no actual image in mind but knew that my starting point was roughly from where the picture was made. It was bitterly cold and some of the docks were frozen – something I hadn't seen for a few years.

Camerawork: Camera: Canon EOS 5D
Lens: Canon 24-105mm f/4L IS USM at 58mm
Exposure: 3.2 seconds at f22
Filtration: 0.3 ND hard graduated
Other: Minus 1 exposure compensation, ISO 50

When I handed the card to Jane, she told me she would save opening it until after her planned operation. Barry later told me that the card reduced her to tears and that she would treasure it forever. It was a moment for me to savour. **CM**

Reflections give us the opportunity to add symmetry to our compositions. If there had been any more ripples on the water I am sure Clive would have left his camera in the bag. There is a bright light and its reflection on the extreme left of frame that I might be tempted to remove. Given his motivation for making this image he surely deserved such fantastic conditions. **PM**

On location:
'On Location'

'Just thought I'd drop you a line to say I'd read your [*Outdoor Photography*, 'On Location'] article and thought it was really good. Your critique of my picture was, in my view, spot on. I also thought the water too bright. The other comments regarding thought process and composition were a much needed confidence boost so thank you! I was also impressed with your treatment of the bridge at Clumber. I must confess that I never considered black and white or toned images on the day and have kicked myself for not doing so. I used to try converting to B&W if I wasn't happy with the colour image but liked the composition, and seeing your sepia image made me aware that I'm not considering all the options enough. There's always something to learn. Many thanks again for the constructive input!'

Phil and I write a monthly 'On Location' article for *Outdoor Photography* magazine, which is based in the UK. This involves asking three readers to join us at a scenic location, where for several hours we all take photographs of the subjects it has to offer, regardless of the weather conditions.

The readers each submit three photographs – their favourite and two others that they aren't so happy with, plus a critique of each image. One of us then writes a more detailed constructive critique about their favourite image.

In case you are thinking we get off lightly, that's not so – we also have to submit an image taken on the same day, for inclusion in the article. In addition to providing the participants with helpful feedback, the aim of the exercise is to promote self-criticism and encourage readers to put more care and thought into their picture making. We want those taking part and the magazine's readership as a whole to produce images they can be proud of and take pleasure in showing to others.

On a more humbling note, feedback can make a difference to one's attitude towards life, whilst showing the power of photography. I once replayed a message left on my answerphone:

'My wife has just received one of your greetings cards of the poppy fields in Spain. She is terminally ill with cancer. She has been in very low spirits for some time but your beautiful picture has lifted her considerably. I can't thank you enough.' He left no name or number, but I will never forget those words. **CM**

Take note

Try writing notes about your experiences and what you are aiming to achieve in your photographs. Articulating our ideas often helps to reveal verbally what we are trying to achieve visually.

Acknowledgements

We would like to sincerely thank Eddie Ephraums who has worked tirelessly on the excellent design of this book. He is a never-ending source of inspiration and the occasional good joke. We have shared many hilarious moments during the making of *Finding the Picture* and look forward to many more.

Grateful thanks also go to Stuart Cooper, Senior Commissioning Editor of Aurum Press, for his patience, excellent editing and proof-reading skills and for believing in us.

To all those photographers who have inspired us, in particular Charlie Waite, Joe Cornish and David Ward; and to all those who may have been inspired *by* us, who might wish to share our passion for photography in the future – we offer our sincere gratitude.

First published in 2009 by Argentum an imprint of Aurum Press Ltd,
7 Greenland Street, London NW1 0ND.

A catalogue record for this book is available from the British Library.

ISBN 978 1 902538 58 7

Designed by Eddie Ephraums.

Printed in Singapore